SLAYER STATS

THE COMPLETE INFOGRAPHIC GUIDE
TO ALL THINGS BUFFY

SLAYER STATS

THE COMPLETE INFOGRAPHIC GUIDE
TO ALL THINGS BUFFY

Simon Guerrier
and Steve O'Brien

INSIGHT ◉ EDITIONS

San Rafael, California

IN EVERY GENERATION
THERE IS A CHOSEN ONE.

SHE ALONE WILL STAND AGAINST
THE VAMPIRES, THE DEMONS,
AND THE FORCES OF DARKNESS.

SHE IS THE SLAYER.

CONTENTS

INTRODUCTION

"ARE YOU SURE THIS IS A GOOD IDEA?"
— DARLA, *1-01 WELCOME TO THE HELLMOUTH*

It's been twenty-one years since Buffy Summers staked her first vampire on TV, and this extraordinary series is now widely regarded as one of the greatest ever made. Its proudly feminist heart, laugh-out-loud lines, tear-jerking drama, knowing pop-culture savviness, and rich, sophisticated storytelling . . . For all the talk of *The Sopranos* ushering in the era of quality television, well, *Buffy* was there first!

This book is a celebration of the whole series—which is no small undertaking.

To watch all 144 episodes takes 4 days, 5 hours, 17 minutes, and 50 seconds. That's not including the time taken to load the DVDs and sit through the menu screens, let alone skip back through an episode to check important details like whether running into the door of that van in *3-09 The Wish* knocks Giles unconscious or just knocks him over.

(See page 44 for the answer to that one.)

We've dedicated *months* to watching and rewatching all the episodes to compile this exhaustive visual guide. Along the way, we've had to impose a few rules:

We've mainly focused on the 144 TV episodes of *Buffy the Vampire Slayer*, not Angel's own spin-off series or Buffy's further adventures in film, books, comics, or anywhere else.

Wherever possible, the graphics are based on hard facts and numbers provided in dialogue or action on-screen, rather than on our own opinions.

We've had to use our judgment in places—for example, we count the destruction of robots as killings, even if robots aren't exactly alive to begin with.

Only the worst sort of writers would base a whole graphic on puns or bad jokes—so we did.

Our aim was to produce a fun, surprising, and sometimes boggling perspective on Buffy's adventures. As a result, we think we know Buffy pretty well. We've even got the evidence to suggest what she might think of what we've done:

After seven seasons on TV, Buffy has no need for Watchers anymore. Giles, her original Watcher, long-term mentor, and friend, can't tell her what to do, and the Watchers' Council of

Britain has been entirely blown up. When Buffy shares her power with all the potential Slayers around the world, it seems this incredible force of young women will now fend for themselves . . .

. . . with no need for awkward, nerdy Englishmen watching what they get up to and scribbling it down in a book.

—*Simon and Steve*

BUFFY ANNE SUMMERS

**ESSENTIAL INFORMATION ON THE CHOSEN ONE,
WHO SAVES THE WORLD A LOT**

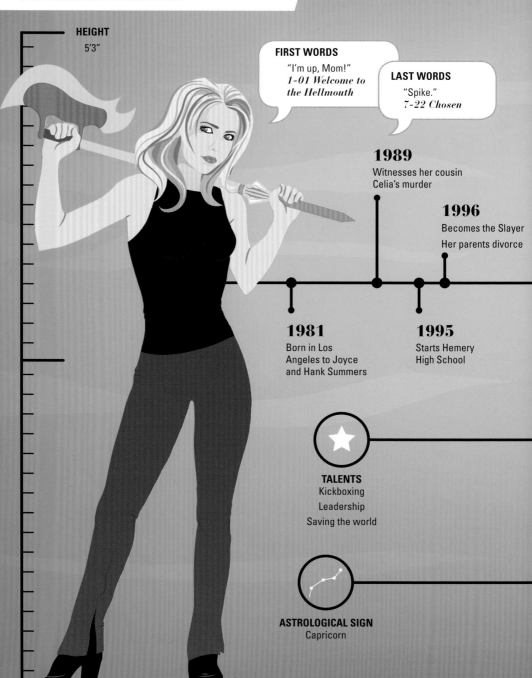

HEIGHT
5'3"

FIRST WORDS
"I'm up, Mom!"
*1-01 Welcome to
the Hellmouth*

LAST WORDS
"Spike."
7-22 Chosen

1989
Witnesses her cousin
Celia's murder

1996
Becomes the Slayer
Her parents divorce

1981
Born in Los
Angeles to Joyce
and Hank Summers

1995
Starts Hemery
High School

TALENTS
Kickboxing
Leadership
Saving the world

ASTROLOGICAL SIGN
Capricorn

LOVES

Brooding, very
old vampires

Mr. Gordo

Boots

HATES

Guns

Letting her friends down

Kathy Newman (her
college roommate)

144
(100%)

EPISODE COUNT

1997

Starts Sunnydale High

Meets Angel

Dies for the first time
during a battle with the
Master

BUFFY SUMMERS

2001

Joyce dies

Dies for the second time
by throwing herself into an
interdimensional portal

Is brought back to life by
Willow

Gets it on with Spike

BUFFY SUMMERS

1999

Enrolls at UC
Sunnydale

1998

Leaves Sunnydale to
become a diner waitress
in Los Angeles

2000

Starts dating Riley

Dawn arrives

2003

Leads the potential
Slayers into a battle
against the Turok-Han
vampires

HUMANS
15
(7.08%)

ROBOTS
4.5*
(2.12%)

SPIRIT BEARS
1
(0.47%)

DEMONS
59.5*
(28.07%)

KILL CHART

VAMPIRES
132
(62.26%)

* When Buffy kills Moloch at the end of *1–08 I, Robot . . . You, Jane*,
he is half-demon, half-robot, so each category is awarded 0.5 points.

MAP OF SUNNYDALE

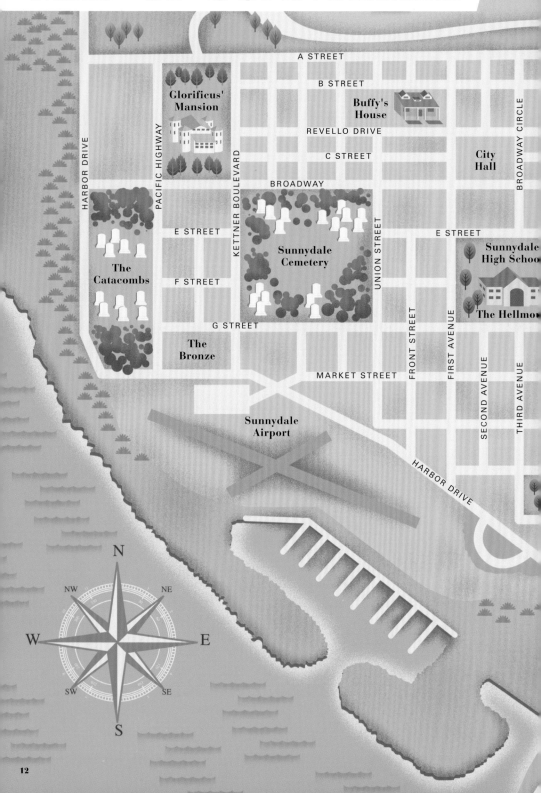

A STREET

B STREET

Glorificus'
Mansion

Buffy's
House

REVELLO DRIVE

C STREET

City
Hall

HARBOR DRIVE

PACIFIC HIGHWAY

KETTNER BOULEVARD

BROADWAY CIRCLE

BROADWAY

E STREET

Sunnydale
Cemetery

UNION STREET

E STREET

Sunnydale
High Schoo

The
Catacombs

F STREET

The Hellmo

G STREET

FRONT STREET

FIRST AVENUE

SECOND AVENUE

THIRD AVENUE

The
Bronze

MARKET STREET

Sunnydale
Airport

HARBOR DRIVE

N

NW NE

W E

SW SE

S

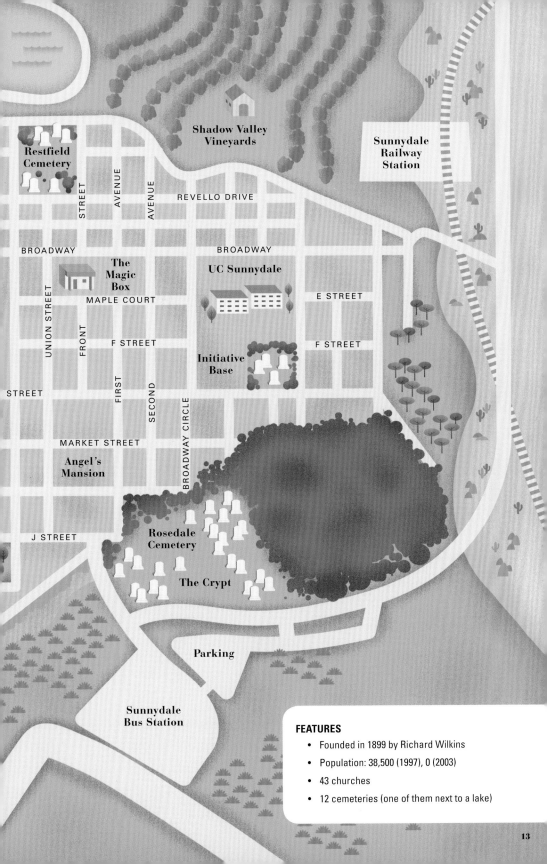

Restfield Cemetery

STREET

AVENUE

AVENUE

Shadow Valley Vineyards

Sunnydale Railway Station

REVELLO DRIVE

BROADWAY

BROADWAY

UNION STREET

The Magic Box

UC Sunnydale

E STREET

MAPLE COURT

FRONT

F STREET

Initiative Base

F STREET

STREET

FIRST

SECOND

BROADWAY CIRCLE

MARKET STREET

Angel's Mansion

J STREET

Rosedale Cemetery

The Crypt

Parking

Sunnydale Bus Station

FEATURES

- Founded in 1899 by Richard Wilkins
- Population: 38,500 (1997), 0 (2003)
- 43 churches
- 12 cemeteries (one of them next to a lake)

BEFORE THE SLAYER

THE HISTORY OF SUNNYDALE PRIOR TO BUFFY'S ARRIVAL

[date unknown]

In what will one day be the town of Sunnydale, a portal between this reality and a hell dimension allows demons to pass into our world. *1-02 The Harvest*

On an unknown date, the portal is closed beneath the Seal of Danzalthar. *7-16 Storyteller*

Some time after this in a nearby valley, the last pure demon is killed by a Slayer using the M? scythe, which is then embedded in the rock. A pagan temple is founded around the site of the rock. *7-21 End of Days*

c. 11,000 BC

The Chumash—a Native American people—establish themselves in the area and throughout what will later be called California.

AD 1542

First contact between European settlers and the Chumash.

1770

Spanish settlers arrive in force to claim Chumash territories.

The settlers call the area "Boca del Infierno"—the Hellmouth—suggesting they experience demonic activity. *1-02 The Harvest*

A monastery is founded on the site of the pagan temple that houses the M? scythe. *7-21 End of Days*

The old Sunnydale Mission is founded. The Chumash are imprisoned, forced into labor, and herded like animals into missions where they contract diseases such as malaria, smallpox, and syphilis. The few Chumash who rebel are hanged. When a group is accused of stealing cattle, the Spanish kill men, women, and children and cut off ears to show their accusers as proof. *4-08 Pangs*

1812

A huge earthquake—possibly summoned by the Chumash—buries the old Sunnydale Mission. *4-08 Pangs*

1824

A wider Chumash uprising takes place in what is now Santa Barbara County.

1937

Following a rash of murders, the Master tries to open the Hellmouth, but instead unleashes an earthquake that swallows half the town—and him too. *1-02 The Harvest*

1949 to 1960

The Lowell House for Children houses up to 40 adolescents from the area, but director Genevieve Holt imposes a harsh and abusive regime. *4-18 Where the Wild Things Are*

1932

An earthquake swallows the Satanist church at Kingman's Bluff. *6-22 Grave*

1955

Sunnydale High School is built sometime before this year, with its library located directly above the Hellmouth. James Stanley is a student and Grace Newman a teacher. *2-19 I Only Have Eyes for You*

1903

Wilkins marries Edna May. *3-19 Choices*

1962

The Lowell House is now part of UC Sunnydale and its students win a trophy. *4-18 Where the Wild Things Are*

c. 1899

The demon Balthazar and his acolytes, El Eliminati, are defeated in the Sunnydale area, probably by Wilkins. A wealthy landowner named Gleaves takes Balthazar's strength-giving amulet, and it is buried with him when he dies. *3-14 Bad Girls*

c. 1986

Xander and Willow Rosenberg attend kindergarten together and become lifelong friends. *6-22 Grave*

Late 1800s

Sorcerer Richard Wilkins is living in Sunnydale. Oz finds his photograph more than 100 years later in 1999 and he looks no different. *3-17 Enemies*

According to Faith, Mayor Richard Wilkins "built"—or perhaps founded—Sunnydale for demons to feed on, in exchange for their helping in his ascension. *3-17 Enemies*

1997

A year after becoming the Slayer, 16-year-old Buffy Summers moves to Sunnydale with her mother, Joyce. Rupert Giles arrives in Sunnydale at roughly the same time, assigned as Buffy's Watcher. *1-01 Welcome to the Hellmouth*

ANATOMY OF A SLAYER

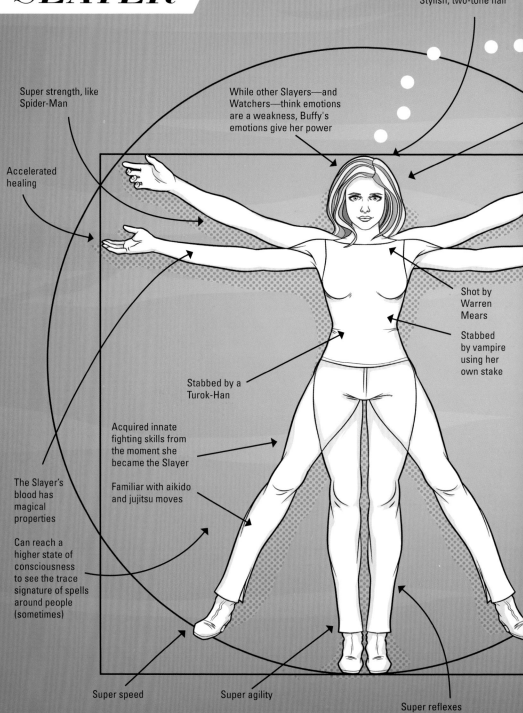

Stylish, two-tone hair

Super strength, like Spider-Man

While other Slayers—and Watchers—think emotions are a weakness, Buffy's emotions give her power

Accelerated healing

Shot by Warren Mears

Stabbed by vampire using her own stake

Stabbed by a Turok-Han

Acquired innate fighting skills from the moment she became the Slayer

The Slayer's blood has magical properties

Familiar with aikido and jujitsu moves

Can reach a higher state of consciousness to see the trace signature of spells around people (sometimes)

Super speed

Super agility

Super reflexes

Sometimes dreams of real events to come

WHAT MAKES BUFFY BUFFY?

She is *always* thinking of herself.

The only guy that ever liked her turned into a vicious killer and had to be put down like a dog.

Love the hair. It just *screams* street urchin!

CORDELIA'S VERDICT

Sucks to be you.

FAITH'S VERDICT

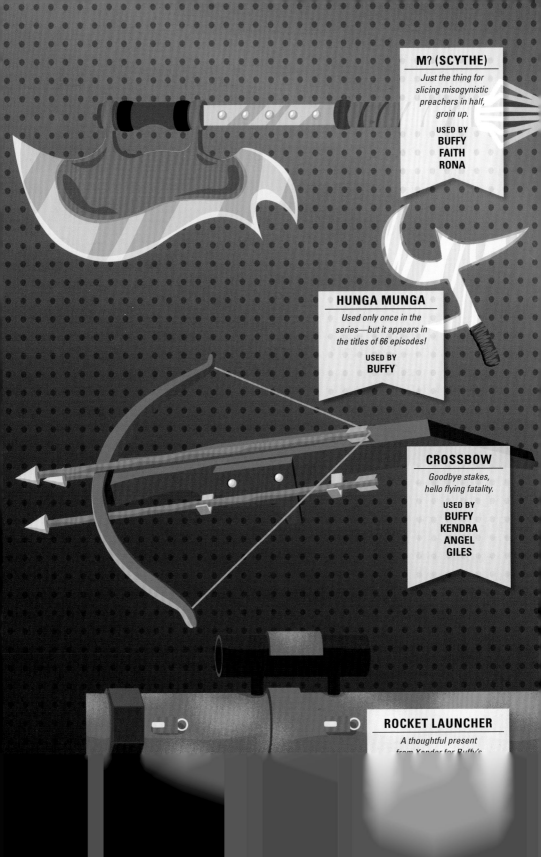

M? (SCYTHE)

Just the thing for slicing misogynistic preachers in half, groin up.

USED BY
BUFFY
FAITH
RONA

HUNGA MUNGA

Used only once in the series—but it appears in the titles of 66 episodes!

USED BY
BUFFY

CROSSBOW

Goodbye stakes, hello flying fatality.

USED BY
BUFFY
KENDRA
ANGEL
GILES

ROCKET LAUNCHER

A thoughtful present from Xander for Buffy's

STABBY POINTY THINGS

BUFFY'S MORE THAN JUST A STAKE HOLDER

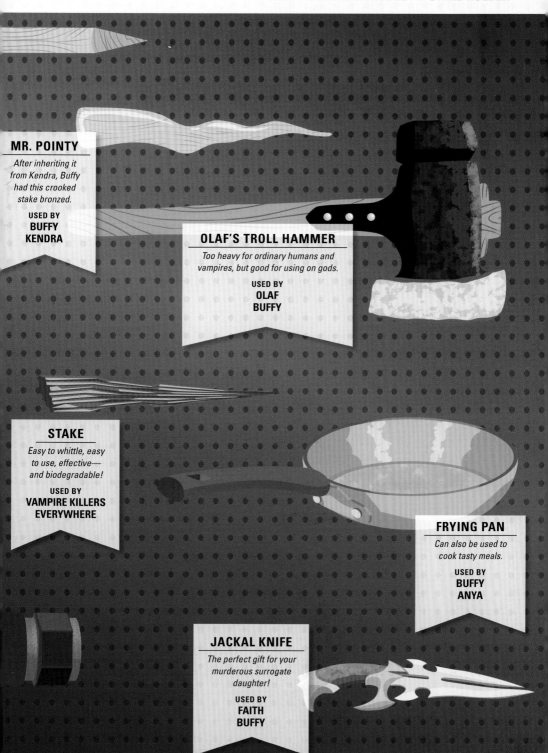

MR. POINTY

After inheriting it from Kendra, Buffy had this crooked stake bronzed.

USED BY
BUFFY
KENDRA

OLAF'S TROLL HAMMER

Too heavy for ordinary humans and vampires, but good for using on gods.

USED BY
OLAF
BUFFY

STAKE

Easy to whittle, easy to use, effective—and biodegradable!

USED BY
VAMPIRE KILLERS
EVERYWHERE

FRYING PAN

Can also be used to cook tasty meals.

USED BY
BUFFY
ANYA

JACKAL KNIFE

The perfect gift for your murderous surrogate daughter!

USED BY
FAITH
BUFFY

BATTLE OF THE SLAYERS

THERE CAN BE ONLY ONE—EXCEPT FOR THE *OTHER* ONES . . .

ON-SCREEN BATTLES

BUFFY VS KENDRA YOUNG

2-09 What's My Line (Part 1)
Kendra sees Buffy smooching Angel and
assumes she's a vampire too. Awkward.

★ DRAW ★

ON-SCREEN BATTLES

BUFFY VS FAITH

3-07 Revelations
Faith is told to fight Buffy by her wicked
Watcher, Gwendolyn Post.

★ DRAW ★

4-15 This Year's Girl
Faith holds Buffy's mom hostage in Buffy's
own house.

★ DRAW ★

3-17 Enemies
Faith is angry after being duped by Buffy
and Angel.

★ DRAW ★

4-16 Who Are You?
Buffy wants her body back.

★ DRAW ★

3-22 Graduation Day (Part 2)
Faith shoots Angel with a poisoned arrow,
and Buffy needs Faith's blood to heal him.

★ BUFFY WINS ★

OTHER SLAYERS

NAME	FROM	SLAYER DATES	WATCHER	ON-SCREEN KILLS	NO. EPISODES	KILLS PER EPISODE	FIRST APPEARANCE
Kendra Young	Jamaica	1997–1998	Sam Zabuto	1	3	0.33	2-09 What's My Line (Part 1)
Faith	Boston	1998–	Unknown woman; Gwendolyn Post	22	20	1.1	3-03 Faith, Hope & Trick
Sineya	Africa	????	Shadow Men	0 (Kills Xander and Giles in dream.)	3	0	4-22 Restless
Xin Rong	China	????–1900	Bernard Crowley	0	1	0	5-07 Fool for Love
Nikki Wood	New York	????–1977	Unknown	0	2	0	5-07 Fool for Love
A-manda	Sunnydale	2003	None	1	10	0.1	7-04 Help
Kennedy	New York	2003–	None	1	13	0.08	7-10 Bring on the Night
Vi	Unknown	2003–	None	5	8	0.63	7-11 Showtime
Rona	Unknown	2003–	None	1	10	0.1	7-11 Showtime
Chao-Ahn	Shanghai	2003–	None	1	6	0.17	7-14 First Date
Shannon	Unknown	2003–	None	0	3	0	7-18 Dirty Girls

SLAYERS SLAIN

Xin Rong	Killed by Spike
Nikki Wood	Killed by Spike
Kendra Young	Killed by Drusilla
A-manda	Killed by a Turok-Han

BIG BAD LINEUP

WHICH BIG BAD IS BIGGEST?

7
6
5
4
3
2
1
0

THE MASTER
APPEARS IN:
Seasons 1–3, 7
9 episodes total

THE ANOINTED ONE
APPEARS IN:
Seasons 1–2
6 episodes total

SPIKE
APPEARS IN:
Seasons 2–7
97 episodes total

6
5
4
3
2
1
0

MAYOR RICHARD WILKINS III (HUMAN FORM)
APPEARS IN:
Seasons 3–4, 7
14 episodes total

THE MAYOR (OLVIKAN FORM)
APPEARS IN:
Season 3
1 episode

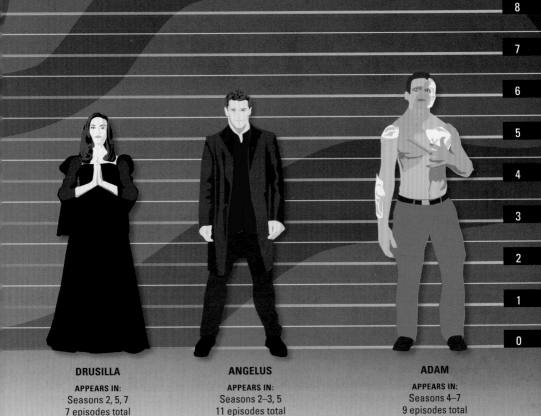

8
7
6
5
4
3
2
1
0

DRUSILLA
APPEARS IN:
Seasons 2, 5, 7
7 episodes total

ANGELUS
APPEARS IN:
Seasons 2–3, 5
11 episodes total

ADAM
APPEARS IN:
Seasons 4–7
9 episodes total

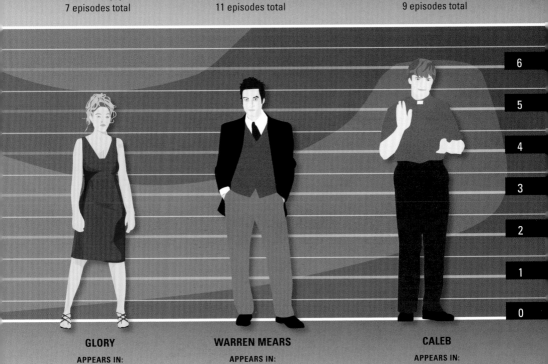

6
5
4
3
2
1
0

GLORY
APPEARS IN:
Seasons 5–7
13 episodes total

WARREN MEARS
APPEARS IN:
Seasons 5–7
16 episodes total

CALEB
APPEARS IN:
Season 7
5 episodes total

BIG BATTLES—
THE MASTER

1-12 PROPHECY GIRL

1. The trapped Master hypnotizes Buffy. (32:41)

2. The trapped Master kills Buffy—and her blood sets him free. (33:38)

3. Xander saves Buffy using CPR. (35:36)

4. Buffy fights the Master. (40:14)

5. Buffy impales the Master and he turns to dust. (41:04)

6. Months later, Buffy smashes the Master's skeleton—ensuring he can't return. (38:05 into *2-01 When She Was Bad*)

KEY DATES

[date unknown]
The Master is sired—all that is known is he's as old as any vampire on record.

1609
The Master sires Darla in Virginia.

1760
The Master meets Angel.

1937
The Master attempts to open the Hellmouth in Sunnydale, but causes an earthquake. A mystical force traps him underground.

1997
The Master finally gains his freedom by killing Buffy, but she recovers and kills him back. Later, she smashes his bones to dust.

> But prophecies are tricky creatures. They don't tell you everything. You're the one that sets me free! If you hadn't come, I couldn't go. Think about that!

THE HORROR, THE HORROR
To provoke Buffy, vampires kill Sunnydale students, including friends of Willow and Cordelia

THE HIGH COST OF WINNING
Buffy dies—for a short while

Minor cuts, bruises, and a soggy prom dress

THE HARVEST
And like a plague of boils, the race of man covered the Earth. But on the third day of the newest light would come the Harvest. And the blood of men will flow as wine when the Master will walk among them once more. The Earth will belong to the old ones. And hell itself will come to town.

THE PERGAMUM CODEX
The Master shall rise, and the Slayer [shall die].

WILLOW DANIELLE ROSENBERG

"I AM A SHE-WITCH, A VERY POWERFUL SHE-WITCH — OR WITCH, AS IS MORE ACCURATE. I AM NOT TO BE TRIFLED WITH . . ."
— WILLOW, *7-09 NEVER LEAVE ME*

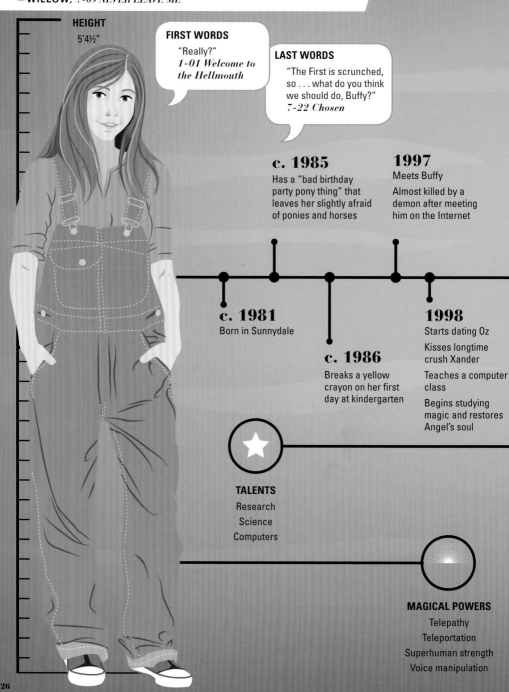

HEIGHT
5'4½"

FIRST WORDS
"Really?"
1-01 Welcome to the Hellmouth

LAST WORDS
"The First is scrunched, so . . . what do you think we should do, Buffy?"
7-22 Chosen

c. 1985
Has a "bad birthday party pony thing" that leaves her slightly afraid of ponies and horses

1997
Meets Buffy
Almost killed by a demon after meeting him on the Internet

c. 1981
Born in Sunnydale

c. 1986
Breaks a yellow crayon on her first day at kindergarten

1998
Starts dating Oz
Kisses longtime crush Xander
Teaches a computer class
Begins studying magic and restores Angel's soul

TALENTS
Research
Science
Computers

MAGICAL POWERS
Telepathy
Teleportation
Superhuman strength
Voice manipulation

LOVES
A Charlie Brown Christmas

Cats

The "We Hate Cordelia" Club

HATES
Frogs

Spiders

Cordelia

144
(100%)

EPISODE COUNT

1999
Willow's mom, under a demon's spell, tries to murder her

Meets her alternate reality doppelgänger

Joins UC Sunnydale

Breaks up with Oz

2001
Attacks Glory after the hell goddess "brain-sucks" Tara—ouch

2002
Kills Warren after he murders Tara

Tries to destroy the world, is stopped by Xander

2003
Begins a relationship with Kennedy

Performs a spell to infuse every potential Slayer in the world with powers, helping to defeat the First Evil

2000
Falls in love with Tara

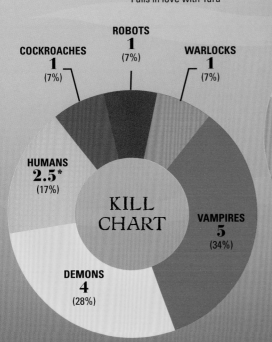

KILL CHART

COCKROACHES
1
(7%)

ROBOTS
1
(7%)

WARLOCKS
1
(7%)

HUMANS
2.5*
(17%)

VAMPIRES
5
(34%)

DEMONS
4
(28%)

PERSONALITY CHART

KIND
7%

SHY
15%

GEEKY
13%

AWKWARD
10%

BRAVE
55%

*0.5 shared with Xander.

GEEK CHIC

CORDELIA ON THE SCOOBIES' WORST FASHION DISASTERS

Pink top that matches her vest while at the same time conveying she's not bothered.

A vest top that says, "Hey, I'm a furry ice cream." Dirt-brown, tie-dyed pants that look like her clothes have an infection.

Overall look: "I sleep rough around Venice Beach."

I think the T-shirt's meant to be ironic. Or maybe all of it is.

Sure, you're asked to be a bridesmaid. But given this green travesty, how much do you really like the bride?

BUFFY

I get it. You're busy slaying vampires and whatever. You don't have time to look good. But looking this bad must take special effort, too.

Overalls. Practical. Really rocking the plumber chic.

WILLOW

Poor Willow. So clever in some ways like being able to read, but so hopeless with the important things like clothes and boys and did I mention clothes?

Why can't she just dress like a grown-up?

Don't even get me started on her hats.

Trust me—there's no danger of a clothes fluke here.

Why do all her clothes have such stupid things on them?

Jumper like a hotel carpet.

You know, the eye patch suits him.

Punch and kick him, and you don't ever have to see his face. What's not to like?

Short sleeves over long sleeves. Honestly?!

Just one example of his hideous, hideous shirts.

Red pants like rich old people wear.

I'm going to puke. Put it away!

XANDER

This is a carefully cultivated ensemble. It proclaims, "I spent last night asleep in the dump."

Love, Cordelia

MAGICAL ARTIFACTS

MUST-HAVE ACCESSORIES FOR THE FASHIONABLE SLAYER-ABOUT-TOWN!

THE SCYTHE

WHAT DOES IT DO?

Otherwise known as the M?, the Scythe embodies the essence of the Slayer.

WHERE WAS IT FOUND?

In the rock beneath Shadow Valley Vineyards in Sunnydale by Buffy while she was looking for a weapon with which to defeat the First Evil.

WHAT HAPPENED TO IT?

Willow used its magical power to make all the Potentials become Slayers simultaneously. Buffy and the Slayers shared the Scythe among them to defeat the Turok-Han.

THE GEM OF AMARA

WHAT DOES IT DO?

A mystical ring that grants vampires increased powers and the ability to survive a staking.

WHERE WAS IT FOUND?

Found by Harmony in a tomb in Sunnydale—while her boyfriend, Spike, was searching for it!

WHAT HAPPENED TO IT?

Sent by Buffy to Angel in Los Angeles.

AMULET OF BALTHAZAR

WHAT DOES IT DO?

It seems that when the demon Balthazar had this amulet taken from him, he lost most of his powers.

WHERE WAS IT FOUND?

In the tomb of a Sunnydale landowner named Gleaves, where it was recovered by Balthazar's minions.

WHAT HAPPENED TO IT?

Last seen in the possession of Angel.

INCA SACRED SEAL

WHAT DOES IT DO?

Created in the 12th century (approximately) by Inca priests, the Seal prevented sacrificed princesses from waking from their death.

WHERE WAS IT FOUND?

It was never lost—it was on display at a museum in Sunnydale.

WHAT HAPPENED TO IT?

Broken by Sunnydale High student Rodney Munson. (D'oh!)

GLOVE OF MYHNEGON

WHAT DOES IT DO?

Fires lightning.

WHERE WAS IT FOUND?

In a crypt in Restfield Cemetery, Sunnydale.

WHAT HAPPENED TO IT?

Destroyed after Buffy separated it from Gwendolyn Post by cutting off her arm.

ORBS OF NEZZLA'KHAN

WHAT DO THEY DO?

They give superhuman strength and physical invulnerability to whoever is in possession of them.

WHERE WERE THEY FOUND?

In a cave, guarded behind a barrier that only Nezzla demons can pass through—and Jonathan, while wearing a Nezzla skin.

WHAT HAPPENED TO THEM?

Crushed by Buffy.

DAGON SPHERE

WHAT DOES IT DO?

Protects the person holding it from Glory.

WHERE WAS IT FOUND?

Given to Buffy by a monk of the Order of Dagon.

WHAT HAPPENED TO IT?

Crushed to smithereens by Glory.

URN OF OSIRIS

WHAT DOES IT DO?

Helps Willow bring Buffy back from the dead.

WHERE WAS IT FOUND?

Being auctioned on eBay by a desert gnome in Cairo.

WHAT HAPPENED TO IT?

Shattered by the Hellions road gang.

SHADOW CASTERS

WHAT DO THEY DO?

Once activated, Shadow Casters will open a portal through time and space.

WHERE WERE THEY FOUND?

Originally owned by the first Slayer, they were given to Buffy by Nikki Wood's son, Robin.

WHAT HAPPENED TO THEM?

Last used by Dawn and Xander.

WORD OF VALIOS

WHAT DOES IT DO?

Used for completing the Sacrifice of Three.

WHERE WAS IT FOUND?

Bought by Rupert Giles.

WHAT HAPPENED TO IT?

Stolen by three Vahrall demons.

SPHERE OF THE FUTURE

WHAT DOES IT DO?

Used by the demon Stewart Burns to show false visions of the future to Xander on his wedding day.

WHERE WAS IT FOUND?

Unknown, but perhaps from the hell dimension to which Anyanka banished Stewart in 1914.

WHAT HAPPENED TO IT?

Last seen when Stewart used it on Xander.

OVU MOBANI MASK

WHAT DOES IT DO?

Causes the dead to become zombies.

WHERE WAS IT FOUND?

Imported from Africa for an art exhibition by Joyce Summers.

WHAT HAPPENED TO IT?

Destroyed by Buffy.

PERGAMUM CODEX

WHAT DOES IT DO?

An ancient book reputed to contain the most complete prophecies about the Slayer's role in the end years.

WHERE WAS IT FOUND?

Giles thought it was lost in the 15th century, but Angel had a copy and gave it to him.

WHAT HAPPENED TO IT?

Last seen after correctly predicting Buffy's death at the hands of the Master.

DARKEST MAGICK

WHAT DOES IT DO?

A book of spells and magic so dark it is usually kept off-limits.

WHERE WAS IT FOUND?

Willow took it from the restricted section of the Magic Box.

WHAT HAPPENED TO IT?

Possibly absorbed by Willow when she turned dark.

ALEXANDER "XANDER" LAVELLE HARRIS

**HIS FRIENDS FIGHT DEMONS AND CAST POWERFUL SPELLS—
BUT HE ONCE SAVED THE WORLD WITH LOVE**

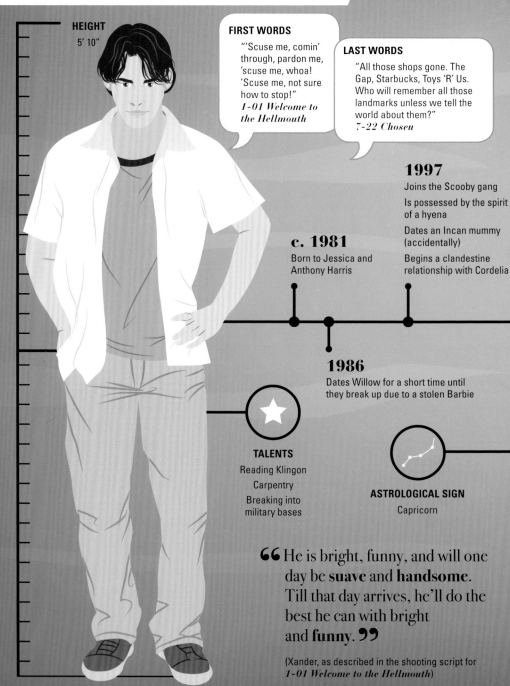

HEIGHT
5' 10"

FIRST WORDS
"'Scuse me, comin'
through, pardon me,
'scuse me, whoa!
'Scuse me, not sure
how to stop!"
*1-01 Welcome to
the Hellmouth*

LAST WORDS
"All those shops gone. The
Gap, Starbucks, Toys 'R' Us.
Who will remember all those
landmarks unless we tell the
world about them?"
7-22 Chosen

1997
Joins the Scooby gang

Is possessed by the spirit
of a hyena

Dates an Incan mummy
(accidentally)

Begins a clandestine
relationship with Cordelia

c. 1981
Born to Jessica and
Anthony Harris

1986
Dates Willow for a short time until
they break up due to a stolen Barbie

TALENTS
Reading Klingon
Carpentry
Breaking into
military bases

ASTROLOGICAL SIGN
Capricorn

> ❝He is bright, funny, and will one
> day be **suave** and **handsome**.
> Till that day arrives, he'll do the
> best he can with bright
> and **funny**.❞
>
> (Xander, as described in the shooting script for
> *1-01 Welcome to the Hellmouth*)

LOVES
Comic books
Sarcasm
Anya

HATES
Learning
Spike
Clowns

143
(99%)

EPISODE COUNT

1999
Loses his virginity to Faith

Begins dating Anya

Graduates high school and embarks on a cross-country road trip (only getting as far as Oxnard as his car breaks down)

Becomes a construction worker

2003
Has his eye gouged out by Caleb

2001
Asks Anya to marry him

1998
Affair with Cordelia ends

2000
Is split into two by the demon Toth

2002
Leaves Anya at the altar

ALSO KNOWN AS
The Zeppo, for being the "useless" part of the Scooby gang (according to Cordelia)

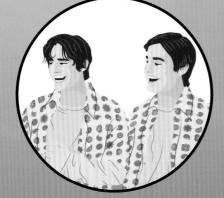

THE TWO XANDERS (from *5-03 The Replacement*)

Courage Humor
Confidence Insecurity

BUTT MONKEY

THE TRIALS AND TRIBULATIONS OF XANDER HARRIS

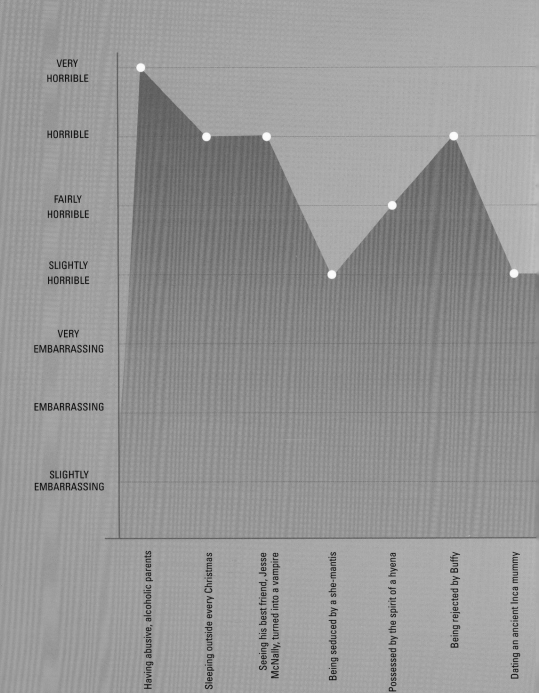

VERY HORRIBLE

HORRIBLE

FAIRLY HORRIBLE

SLIGHTLY HORRIBLE

VERY EMBARRASSING

EMBARRASSING

SLIGHTLY EMBARRASSING

Having abusive, alcoholic parents

Sleeping outside every Christmas

Seeing his best friend, Jesse McNally, turned into a vampire

Being seduced by a she-mantis

Possessed by the spirit of a hyena

Being rejected by Buffy

Dating an ancient Inca mummy

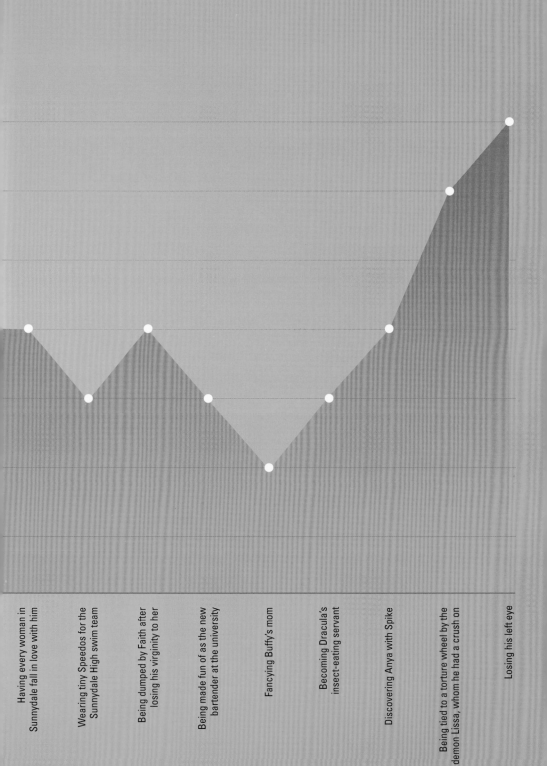

Having every woman in
Sunnydale fall in love with him

Wearing tiny Speedos for the
Sunnydale High swim team

Being dumped by Faith after
losing his virginity to her

Being made fun of as the new
bartender at the university

Fancying Buffy's mom

Becoming Dracula's
insect-eating servant

Discovering Anya with Spike

Being tied to a torture wheel by the
demon Lissa, whom he had a crush on

Losing his left eye

SEEING DOUBLE

"HEY, WAIT TILL YOU HAVE AN EVIL TWIN. SEE HOW *YOU* HANDLE IT!"
"I HANDLED IT FINE." —XANDER AND WILLOW, *5-03 THE REPLACEMENT*

Xander
5-03 The Replacement

The demon Toth hits Xander with the Ferula Gemini, which splits him in half, distilling his personality traits into two separate bodies.

The natural state of the two Xanders is to be together, so Willow just has to say, "Let the spell be ended."

Xander
3-09 The Wish, 3-16 Doppelgangland

Anyanka, the vengeance demon, uses an amulet to grant Cordelia's wish that Buffy never came to Sunnydale, creating an alternative reality where Xander is a vampire.

Buffy kills the vampire Xander before Giles restores reality by destroying the amulet.

Willow
3-09 The Wish, 3-16 Doppelgangland

In the alternate reality created by Anyanka to fulfill Cordelia's wish, Willow also appears as a vampire.

Oz kills the vampire Willow before Giles restores reality by destroying the amulet.

A few weeks later, Anya gets Willow to cast a spell to recover the amulet from the alternate reality—but instead it recovers vampire Willow.

Anya and Willow send vampire Willow back to the alternate reality, just in time to be staked by Oz.

Angel
4-01 The Freshman

Buffy briefly mistakes a random man for Angel.*

Buffybot

5-18 Intervention, 5-22 The Gift, 6-01 Bargaining (Part 1), 6-02 Bargaining (Part 2)

Warren builds a robot version of Buffy for Spike.

The real Buffy dies to save her sister and the world.

The Scoobies use the Buffybot to convince demons that Buffy is still alive and protecting Sunnydale. But they also resurrect Buffy.

The Buffybot is destroyed by the Hellions, a demon road gang.

Warren Mears

6-20 Villains

Warren builds a robot duplicate of himself in his efforts to escape Willow.

Willow destroys the robot duplicate of Warren.

Willow kills Warren.

The First Evil

3-10 Amends, 7-01 Lessons, 7-05 Selfless, 7-07 Conversations With Dead People, 7-08 Sleeper, 7-09 Never Leave Me, 7-10 Bring on the Night, 7-11 Showtime, 7-14 First Date, 7-15 Get It Done, 7-16 Storyteller, 7-18 Dirty Girls, 7-19 Empty Places, 7-20 Touched, 7-21 End of Days, 7-22 Chosen

The First Evil can take the form of anyone dead, and appears as:

Adam (killed by Buffy)

Betty (a victim of Caleb's)

Buffy (killed by the Master and then by herself)

Caleb (killed by Buffy)

Cassie Newton (died of heart failure)

Chloe (killed herself, goaded by the First Evil)

Daniel (killed by Angelus)

Drusilla (sired by Angelus)

Eve (killed by Harbingers of Death)

Glory (killed by Giles)

Jenny Calendar (killed by Angelus)

Jonathan (killed by Andrew)

Joyce (died from a brain aneurysm)

Margaret (killed by Angelus)

The Master (killed by Buffy)

Nikki Wood (killed by Spike)

Richard Wilkins III (killed by Buffy and Giles)

Spike (sired by Drusilla)

Travis (killed by Angelus)

Warren (killed by Willow)

*It's hardly her fault; the random man is played by Angel actor David Boreanaz.

THE WEB

"LOVE'S A FUNNY THING." — SPIKE, *3-08 LOVERS WALK*

Sweet*

Every woman in
Sunnydale except
Cordelia Chase

Tom
Warner

Jesse
McNally

Lori

Cordelia
Chase

Ampata
Gutierrez

RJ
Brooks

Mitch
Fargo

Wesley
Wyndam-Pryce

Kendra
Young

XANDER
HARRIS

BUFFY
SUMMERS

Lissa

Amy
Yip

Larry
Blaisdell

Natalie
French

Julie

Torg

Parker
Abrams

Riley
Finn

Cameron
Walker

Unnamed
building
manager

Sandy

Scott
Hope

Sid the
Dummy

Anya
Jenkins

Faith
Lehane

Olaf the
Troll

WILLOW
ROSENBERG

Billy
Fordham

Veruca

Three
unnamed
young men

SPIKE

Buffybot

Daniel "Oz"
Osbourne

"Malcolm
Black" /
Moloch

Harmony

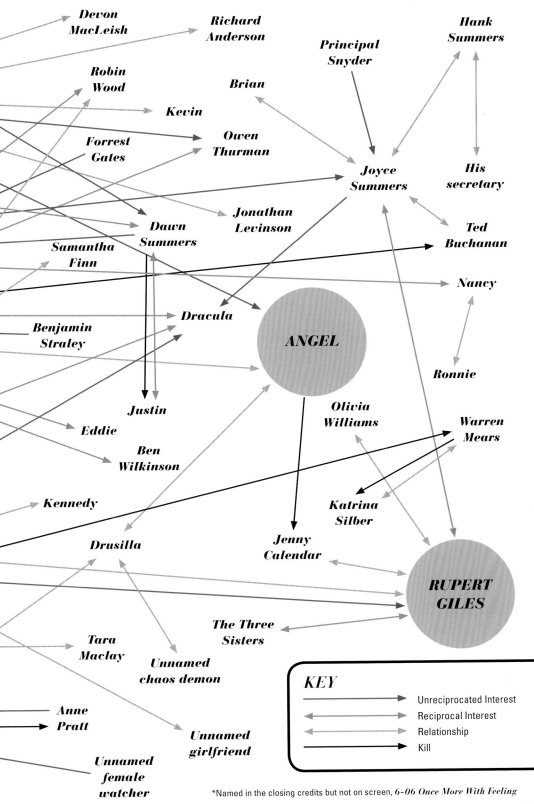

Devon MacLeish

Richard Anderson

Principal Snyder

Hank Summers

Robin Wood

Brian

Kevin

Owen Thurman

Forrest Gates

Joyce Summers

His secretary

Jonathan Levinson

Dawn Summers

Ted Buchanan

Samantha Finn

Nancy

Dracula

ANGEL

Benjamin Straley

Ronnie

Justin

Olivia Williams

Warren Mears

Eddie

Ben Wilkinson

Kennedy

Katrina Silber

Drusilla

Jenny Calendar

RUPERT GILES

The Three Sisters

Tara Maclay

Unnamed chaos demon

Anne Pratt

Unnamed girlfriend

Unnamed female watcher

KEY

Unreciprocated Interest
Reciprocal Interest
Relationship
Kill

*Named in the closing credits but not on screen, *6-06 Once More With Feeling*

39

BIG BATTLES—ANGELUS

2-22 BECOMING (PART 2)

1. Angelus draws his own blood, which lets him pull the sword from Acathla, opening a portal to a hell dimension. (29:33)

2. Spike smacks Angelus. (29:58)

3. Buffy fights Angelus. (32:10)

4. Willow's magic restores Angel's soul. (35:07)

5. Buffy kisses Angel. (36:42)

6. To close the portal, Buffy stabs Angel and sends him into the hell dimension. (37:18)

KEY DATES

1753
Darla sires Angel in Galway, Ireland.

1860
Angelus sires Drusilla in London, England.

1898
Angelus is cursed by Romanian gypsies and has his soul returned to him.

1996
Angel meets the demon Whistler in Manhattan.

Angel observes Buffy after she becomes the Slayer while at Hemery High School in Los Angeles.

1997
Angel and Buffy meet.

1998
Angel sleeps with Buffy, and in that moment of pure happiness the curse is lifted and he loses his soul, becoming Angelus once more.

THE HORROR, THE HORROR

Angelus tortures Giles with visions of Jenny Calendar

Buffy's friends are already suffering, with Kendra Young and Jenny dead, and Willow in the hospital with a head injury

THE HIGH COST OF WINNING

Spike betrays Angelus and Drusilla

Buffy banishes Angel—even though he has his soul back—to the hell dimension

Buffy leaves Sunnydale

He will swallow the world.

And every creature living on this planet will go to hell.

RUPERT GILES

"A SLAYER SLAYS, A WATCHER . . ."
—GILES, *1-01 WELCOME TO THE HELLMOUTH*

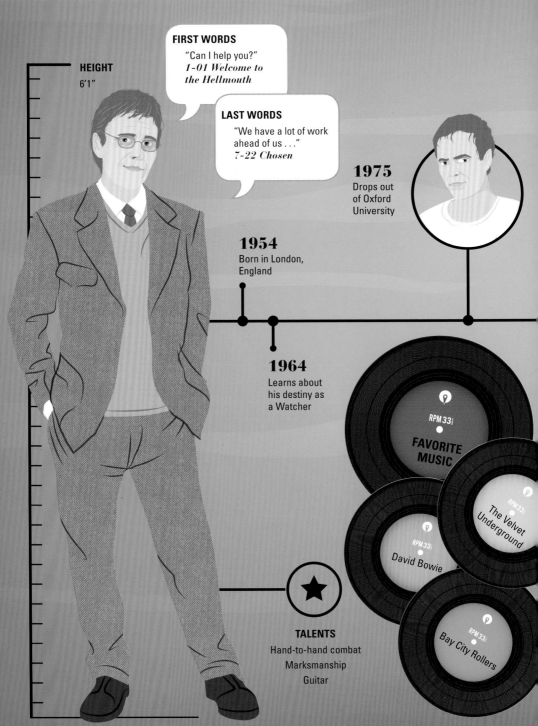

HEIGHT
6'1"

FIRST WORDS
"Can I help you?"
*1-01 Welcome to
the Hellmouth*

LAST WORDS
"We have a lot of work
ahead of us . . ."
7-22 Chosen

1975
Drops out
of Oxford
University

1954
Born in London,
England

1964
Learns about
his destiny as
a Watcher

RPM 33⅓

**FAVORITE
MUSIC**

The Velvet
Underground
RPM 33⅓

David Bowie
RPM 33⅓

Bay City Rollers
RPM 33⅓

TALENTS
Hand-to-hand combat
Marksmanship
Guitar

LOVES
Books
Tea
Halloween

HATES
Technology
Pop music
The modern world

121
(84%)

EPISODE COUNT

100%

Percentage of episodes featuring Giles in which he wipes his glasses

2000
Is turned into a Fyarl demon by Ethan Rayne's spell

Becomes Buffy's Watcher again

1990s
Moves to Sunnydale

1980
Accepts his future as a Watcher

1999
Is fired as Buffy's Watcher and replaced by Wesley Wyndam-Pryce

Begins a relationship with old flame Olivia Williams

2001
Moves back to England after Buffy's death

2002
Returns to Sunnydale

1997
Becomes Watcher to Buffy Summers

Starts dating Sunnydale High teacher Jenny Calendar

NICKNAMES

Snobby

Crusty Old Alfred

Captain Slowpoke

Rupy

Ripper

GILES'S ENGLISH HOMES

Westbury

London

I'M ONLY SLEEPING

ALL THE TIMES GILES IS KNOCKED UNCONSCIOUS

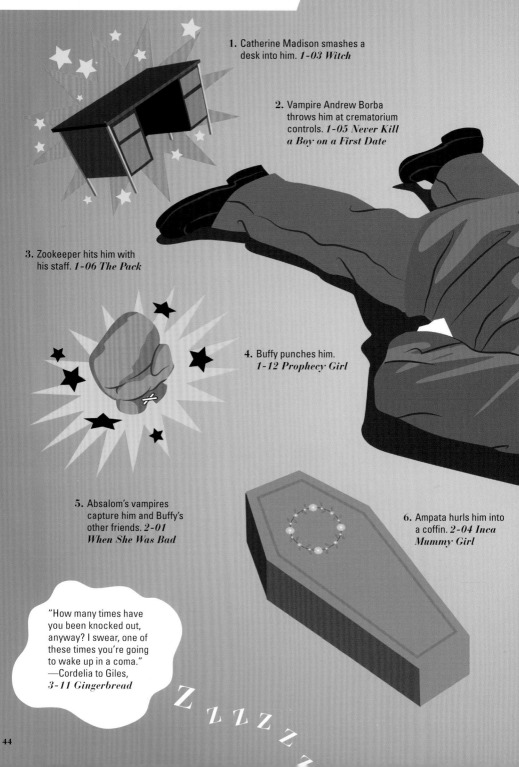

1. Catherine Madison smashes a desk into him. *1-03 Witch*

2. Vampire Andrew Borba throws him at crematorium controls. *1-05 Never Kill a Boy on a First Date*

3. Zookeeper hits him with his staff. *1-06 The Pack*

4. Buffy punches him. *1-12 Prophecy Girl*

5. Absalom's vampires capture him and Buffy's other friends. *2-01 When She Was Bad*

6. Ampata hurls him into a coffin. *2-04 Inca Mummy Girl*

"How many times have you been knocked out, anyway? I swear, one of these times you're going to wake up in a coma."
—Cordelia to Giles, *3-11 Gingerbread*

7. After an encounter with Jenny Calendar while she was possessed by Eyghon, Giles has a dream vision. *2-08 The Dark Age*

8. Giles and the others are unconscious after the Bezoar is killed. *2-12 Bad Eggs*

9. Angelus hits him. *2-17 Passion*

10. Drusilla's gang of vampires beat him up. *2-21 Becoming (Part 1)*

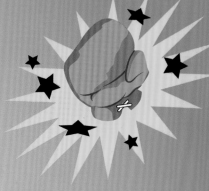

11. Buffy shoots him with a tranquillizer gun. *3-04 Beauty and the Beasts*

12. Vampires Candy and Lyle Gorch knock him out. *3-05 Homecoming*

13. Rogue Watcher Gwendolyn Post hits him. *3-07 Revelations*

14. Drugged by Mothers Opposed to the Occult. *3-11 Gingerbread*

15. Ethan Rayne spikes his drink. *4-12 A New Man*

16. M'Fashnik demon hits him. *6-04 Flooded*

17. He and the others are knocked out by Willow's spell. *6-08 Tabula Rasa*

18. His magical duel with Willow leaves him exhausted. *6-22 Grave*

GILES'S SCOOBY REPORTS

**FOUND IN THE RUINS OF THE HEADQUARTERS OF THE WATCHERS'
COUNCIL OF BRITAIN AFTER THE 2002 EXPLOSION**

Dear Quentin,

Please find enclosed assessments of the Slayer and her entourage
as requested. As always, I'd welcome any comments or insight you
might have.

Rupert

Name: BUFFY SUMMERS

Subject	Comment	Mark
Fighting	Impressive. Buffy shows commendable aptitude and commitment in learning new vampire slaying techniques. Well done.	A+
Attitude	Buffy would do better at her job if she wasn't constantly distracted by boys (particularly those of the vampiric variety). Ahem.	B
General comments	Buffy is an able Slayer, but has a somewhat trying tendency to not take the job seriously. As I've said many, many times, due to her naturally rebellious nature, some flexibility is required in training her.	

SUNNYDALE HIGH

Name: WILLOW ROSENBERG

Subject	Comment	Mark
Fighting	Poor. Willow is, not to put too fine a point on it, hardly cut out for physical conflict.	D
Attitude	Willow shows great enthusiasm and a willingness to learn more about the perils facing our world. She is an efficient researcher and her growing interest in magic is very encouraging. She does, however, put a little too much faith in this "Internet."	A+
General comments	Willow is a resourceful, loyal, and admirably inquisitive member of the "Scooby Gang," as they are inclined to call themselves.	

SUNNYDALE HIGH

Name: XANDER HARRIS

Subject	Comment	Mark
Fighting	Xander has great strength and is an invaluable aid to Buffy in her nighttime patrol at the cemetery. Impressive staking techniques to boot.	B+
Attitude	Though Xander shows commitment in the fight against vampires and demons, his need to always play the class clown does him no favors. I do believe that if Xander could listen more and quip a bit less, it might stand him in good stead.	C+
General comments	Xander's bothersome tendency to see every important meeting as an opportunity to joke around masks, I fear, a deep insecurity. He should trust that his friends like and respect him.	

SUNNYDALE HIGH

Name: CORDELIA CHASE

Subject	Comment	Mark
Fighting	Not one of Cordelia's strong points, lest she breaks a nail or scuffs her highly impractical shoes.	D
Attitude	Cordelia seems terribly uninterested in the various threats to Sunnydale, only seeming to care when the danger threatens a planned shopping trip.	D-
General comments	I'm not even sure why we invite her to our meetings . . . I can't imagine any of the Council members would find much to admire in her.	

SUNNYDALE HIGH

Name: DANIEL "OZ" OSBOURNE

Subject	Comment	Mark
Fighting	Oz's nocturnal activities as a werewolf mean that some nights we're tied up trying to save people from him!	D
Attitude	Oz, I must say, has a laid-back attitude to most things, and his relaxed stoicism can be a welcome tonic to his friends' occasional hysteria.	B
General comments	Oz is a valued member of the Scooby Gang, someone whose wisdom belies his years. He makes some bloody awful music, though.	

GLOSSARY OF BUFFY-ISMS

WATCHER'S DIARY —RUPERT GILES

Entry #1, 10 March 1997

Slayer is willful and insolent. Her abuse of the English language is such that I understand only every other sentence . . .

bad (adj.)
1. Unpleasant or unwelcome.
2. Good. *(noun)*
3. A mistake ("My bad" = "I apologize for my error").

but-face (noun)
What Giles looks like when he's about to say "but."

cookie (noun)
1. Biscuit.
2. Buffy when she's ready to date again.

dust (verb)
To successfully eliminate a vampire.

fang gang (noun)
Inappropriately lighthearted term for a group of vampires.

foamy (adj.)
Descriptive of beer, especially magically affected beer.

five by five (noun)
1. A good, clear signal in radio communications. *(adj.)*
2. As used by Faith: good.

jones (verb)
To desire.

great googly moogly (interjection)

Expression of surprise, such as when your best friend telepathically speaks to you without warning.

McPlasma (noun)

Blood that has not come directly from a human body.

sitch (noun)

Situation. Usually when something's gone wrong.

Princess Margaret

A nickname for Wesley Wyndam-Pryce.

über-suck, the (noun)

Extremely bad, e.g. a student exchange program with a murderous Incan mummy.

smellementary (adj.)

Used to describe a straightforward olfactory deduction.

vamp (noun)

Vampire (casual).

wacky, the (noun)

Irrational behavior when in love.

wig out (verb)

To become excitable or wild.

Bored now

WELCOME TO THE HELLMOUTH

SCHOOL'S OUT FOR SUMMERS

Energy emanating from the Hellmouth causes strange phenomena in the vicinity

Old Sunnydale High (blown up in 1999)

Room directly below school library, with Hellmouth like a crack in the floor

Long chasm through rock

Hell dimension

Three-headed, tentacled demon—seemingly killed in *3-13 The Zeppo*

OPEN AND SHUT

1997
The Master succeeds in opening the Hellmouth, but it is closed again when Buffy kills him. *1-12 Prophecy Girl*

1999
The Sisterhood of Jhe succeed in opening the Hellmouth but Buffy and her friends close it again. *3-13 The Zeppo*

2000
Buffy dives into the Hellmouth to retrieve the last of three Vahrall demons, whose self-sacrifice would have opened the portal again. *4-11 Doomed*

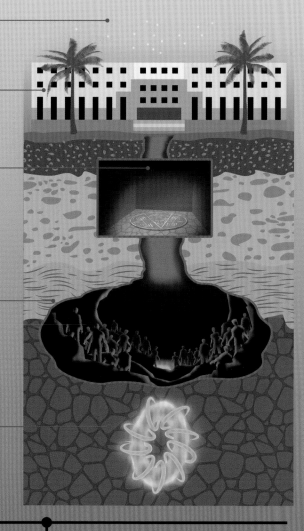

"Even after the Hellmouth was closed, you could still hear it screaming." —Willow, *3-13 The Zeppo*

Energy emanating from the Hellmouth causes strange phenomena in the vicinity

New Sunnydale High (destroyed in 2003)

Room directly below the principal's office contains the Seal of Danzalthar

Huge caverns containing hundreds of Turok-Han vampires

Hellmouth leading to hell dimension

2002

The First Evil convinces Andrew to kill his friend Jonathan so that he bleeds on the Seal of Danzalthar to open the Hellmouth. We later learn Jonathan didn't contain enough blood. *7-07 Conversations with Dead People*

The First Evil cuts Spike so that he bleeds on the Seal of Danzalthar and opens it. *7-09 Never Leave Me*

Having released a Turok-Han vampire, the seal closes again. *7-10 Bring on the Night*

2003

The demon Lissa bleeds Xander to reopen the seal; Principal Wood rescues Xander and the seal closes, chopping off the arm of an emerging Turok-Han. *7-14 First Date*

Possessed students bleed on the seal, but before it can be fully opened, Andrew's tears close it. *7-16 Storyteller*

Buffy, Faith, and the potential Slayers cut themselves to open the seal and face the hundreds of Turok-Han vampires beneath. Spike destroys the vampires and the Hellmouth . . . but Giles says there's another Hellmouth in Cleveland. *7-22 Chosen*

Note: For a history of the Hellmouth before Buffy arrived in Sunnydale, see page **14**.

CLASS OF '99

THE NAMED MEMBERS OF BUFFY'S YEAR AT SUNNYDALE HIGH—AND WHAT BECAME OF THEM

◎ HEIDI BARRIE
fate unknown after 1-06 The Pack

~~LARRY BLAISDELL~~
dies in 3-22 Graduation Day (Part 2)

◎ MICHELLE BLAKE
fate unknown after 3-05 Homecoming

★ LANCE BROOKS
survives, seen in 7-06 Him

◎ LISA CAMPITI
fate unknown after 1-09 The Puppet Show

◎ HOLLY CHARLESTON
fate unknown after 3-05 Homecoming

★ CORDELIA CHASE
survives high school, moves to Los Angeles after 3-22 Graduation Day (Part 2)

~~PETER CLARNER~~
killed by Angel in 3-04 Beauty and the Beasts

◎ LISHANNE DAVIS
fate unknown after 1-03 Witch

◎ KYLE DUFOURS
fate unknown after 1-06 The Pack

◎ LAURA EGLER
fate unknown after 1-10 Nightmares

~~ANYA EMERSON~~
survives high school to die in 7-22 Chosen

◎ CHRIS EPPS
fate unknown after 2-02 Some Assembly Required

◎ MITCH FARGO
fate unknown after 1-11 Out of Mind, Out of Sight

~~DEBBIE FOLEY~~
killed by Peter Clarner in 3-04 Beauty and the Beasts

◎ ERIC GITTLESON
fate unknown after 2-02 Some Assembly Required

◎ AMBER GROVE
suffered burns in 1-03 Witch, but fate after that unknown

~~AMPATA GUTIERREZ~~
dies in 2-04 Inca Mummy Girl

★ ALEXANDER HARRIS
survives

◎ TOR HAUER
fate unknown after 1-06 The Pack

◎ SCOTT HOPE
survives high school, fate unknown after 7-07 Conversations with Dead People

◎ FREDERICK IVERSON
fate unknown after 3-18 Earshot

◎ RHONDA KELLEY
fate unknown after 1-06 The Pack

★ HARMONY KENDALL
becomes a vampire in 3-22 Graduation Day (Part 2), but survives

~~DAVE KIRBY~~
dies in 1-08 I, Robot . . . You, Jane

~~JONATHAN LEVINSON~~
survives high school, dies in **7-07 Conversations with Dead People**

◎ LANCE LINCOLN
fate unknown after **1-06 The Pack**

◎ DEVON MACLEISH
survives high school, fate unknown after **4-19 New Moon Rising**

◎ AMY MADISON
turned into a rat in **3-11 Gingerbread**, permanently turned back into a human in **6-09 Smashed**, fate unknown after **7-13 The Killer in Me**

◎ BLAYNE MOLL
fate unknown after **1-04 Teacher's Pet**

◎ HOGAN MARTIN
fate unknown after **3-18 Earshot**

◎ JACK MAYHEW
fate unknown after **3-20 The Prom**

◎ DANIEL OSBOURNE*
becomes a werewolf, survives high school, fate unknown after **4-19 New Moon Rising**

★ WILLOW ROSENBERG
survives

~~FRITZ SIEGEL~~
dies in **1-08 I, Robot . . . You, Jane**

★ BUFFY ANNE SUMMERS
dies in **1-12 Prophecy Girl**, recovers, survives high school

◎ BEN STRALEY
fate unknown after **2-19 I Only Have Eyes for You**

◎ OWEN THURMAN
fate unknown after **1-05 Never Kill a Boy on the First Date**

◎ LYSETTE TORCHIO
fate unknown after **3-13 The Zeppo**

~~HOLDEN WEBSTER~~
survives high school, does an internship at Sunnydale Mental Hospital, is sired by Spike and dusted by Buffy in **7-07 Conversations with Dead People**

◎ PERCY WEST
survives high school, fate unknown after **4-11 Doomed**

★ TUCKER WELLS
fate unknown after **3-20 The Prom**, but his brother Andrew mentions him in **7-22 Chosen**.

★ JASON WHEELER
has apparently been in the chronic ward of Sunnydale Mental Hospital since graduation **(7-07 Conversations with Dead People)**

KEY

———— Dies before or during graduation

———— Dies after graduation

◎ Fate unkown

★ Survives

* Oz is a year older than Buffy and her friends, but he had to repeat his senior year so graduated with the class of '99.

BIG BATTLES— GRADUATION DAY

3-22 GRADUATION DAY (PART 2)

1. Buffy stabs Faith with the dagger she received from Mayor Wilkins. (41:00—in *3-21 Graduation Day, Part 1*)

2. Buffy shares a dream with Faith in which they make up. (15:16)

3. Mayor Wilkins ascends, becoming a pure demon, the embodiment of Olvikan. (31:03)

4. Buffy taunts Mayor Wilkins with the dagger she used to stab Faith. (35:39)

5. The mayor chases Buffy. (35:57)

6. Buffy lures the mayor into a library full of explosives. (36:36)

KEY DATES

[date unknown]
The demon Olvikan dies and is buried in a volcanic eruption on Kauai.

c. 1199
A sorcerer achieves ascension in the Koskov Valley in the Urals and becomes the embodiment of the demon Lohesh, the four-winged soul-killer.

c. 1997*
Professor of volcanology Lester Worth from Sunnydale uncovers the remains of Olvikan on Kauai.

1999
Worth is murdered by Faith because the mayor hopes to hide the fact that an ascended demon can die.

*We're not told when Worth conducted his work, but it seems likely it was quite recent—otherwise why wouldn't Wilkins have had him murdered sooner?

THE HORROR, THE HORROR
- Buffy and Faith suffer several injuries as a result of their fight
- Mayor Wilkins suffocates the prone Buffy in the hospital

THE HIGH COST OF WINNING
- Many at the graduation ceremony die—including Larry Blaisdell and Principal Snyder
- Harmony Kendall is sired
- Wesley Wyndam-Pryce is hospitalised
- Sunnydale High School is destroyed

Well, I'd get set for some weeping if I were you. I'd get set for a world of hurt. Misery loves company, young man, and I'll be looking to share mine with you and your whore.

ANGEL

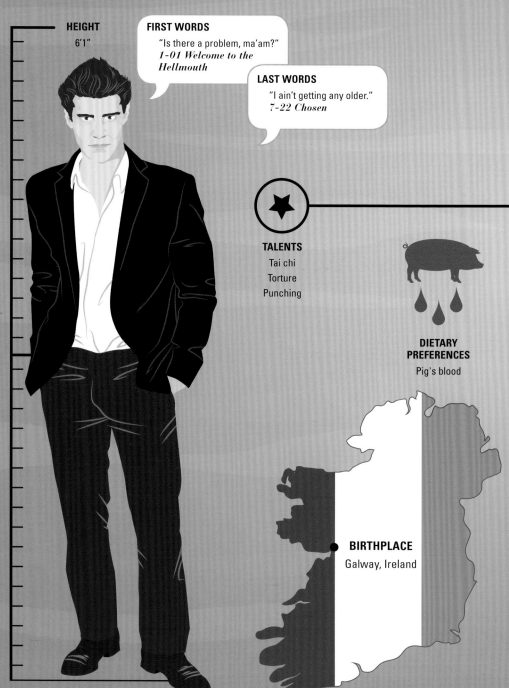

HEIGHT
6'1"

FIRST WORDS
"Is there a problem, ma'am?"
1-01 Welcome to the Hellmouth

LAST WORDS
"I ain't getting any older."
7-22 Chosen

TALENTS
Tai chi
Torture
Punching

DIETARY PREFERENCES
Pig's blood

BIRTHPLACE
Galway, Ireland

LOVES
The color black
Barry Manilow
Sartre

HATES
Dancing
Smiling
Spike

58
(40%)

EPISODE COUNT

Episodes in which Angel smiles **2%**

Episodes in which Angel doesn't smile **98%**

ANGEL'S GIFT TO BUFFY FOR HER

17th
BIRTHDAY

A Claddagh ring

"Wear it with the heart pointing towards you. It means you belong to somebody. Like this. Put it on." *2-13 Surprise*

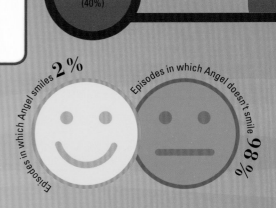

TATTOO
A griffin from the Book of Kells, with the letter *A* beneath it

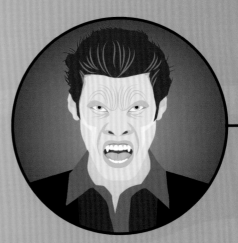

ALTER EGOS
Liam (real name)
Angelus
The Scourge of Europe

ALSO KNOWN AS

1. Captain Forehead (by Spike)

2. Broody Boy (by Cordelia)

3. Angry Puppy (by Buffy)

4. King of Pain (by Riley Finn)

5. Mr. Billowy Coat (by Riley Finn)

HISTORY OF ANGEL

HE'S BEEN AROUND FOR A LONG, LONG TIME

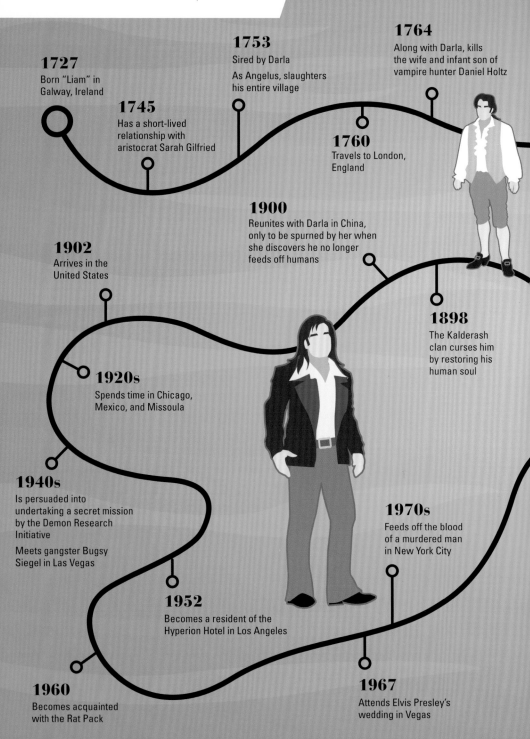

1727
Born "Liam" in
Galway, Ireland

1745
Has a short-lived
relationship with
aristocrat Sarah Gilfried

1753
Sired by Darla
As Angelus, slaughters
his entire village

1764
Along with Darla, kills
the wife and infant son of
vampire hunter Daniel Holtz

1760
Travels to London,
England

1900
Reunites with Darla in China,
only to be spurned by her when
she discovers he no longer
feeds off humans

1902
Arrives in the
United States

1898
The Kalderash
clan curses him
by restoring his
human soul

1920s
Spends time in Chicago,
Mexico, and Missoula

1940s
Is persuaded into
undertaking a secret mission
by the Demon Research
Initiative
Meets gangster Bugsy
Siegel in Las Vegas

1970s
Feeds off the blood
of a murdered man
in New York City

1952
Becomes a resident of the
Hyperion Hotel in Los Angeles

1960
Becomes acquainted
with the Rat Pack

1967
Attends Elvis Presley's
wedding in Vegas

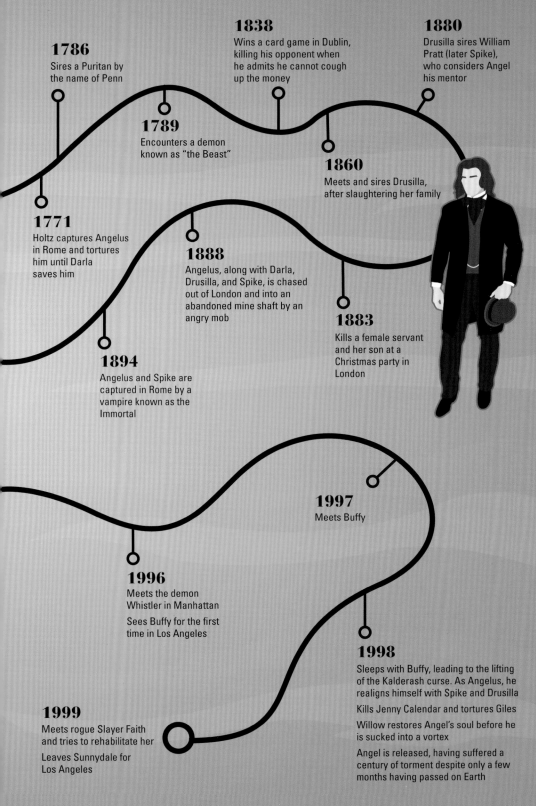

1786
Sires a Puritan by the name of Penn

1838
Wins a card game in Dublin, killing his opponent when he admits he cannot cough up the money

1880
Drusilla sires William Pratt (later Spike), who considers Angel his mentor

1789
Encounters a demon known as "the Beast"

1860
Meets and sires Drusilla, after slaughtering her family

1771
Holtz captures Angelus in Rome and tortures him until Darla saves him

1888
Angelus, along with Darla, Drusilla, and Spike, is chased out of London and into an abandoned mine shaft by an angry mob

1883
Kills a female servant and her son at a Christmas party in London

1894
Angelus and Spike are captured in Rome by a vampire known as the Immortal

1997
Meets Buffy

1996
Meets the demon Whistler in Manhattan

Sees Buffy for the first time in Los Angeles

1998
Sleeps with Buffy, leading to the lifting of the Kalderash curse. As Angelus, he realigns himself with Spike and Drusilla

Kills Jenny Calendar and tortures Giles

Willow restores Angel's soul before he is sucked into a vortex

Angel is released, having suffered a century of torment despite only a few months having passed on Earth

1999
Meets rogue Slayer Faith and tries to rehabilitate her

Leaves Sunnydale for Los Angeles

HOW TO DATE AN ANGEL

COULD YOU DO BETTER THAN BUFFY IN THE ROMANCE STAKES?

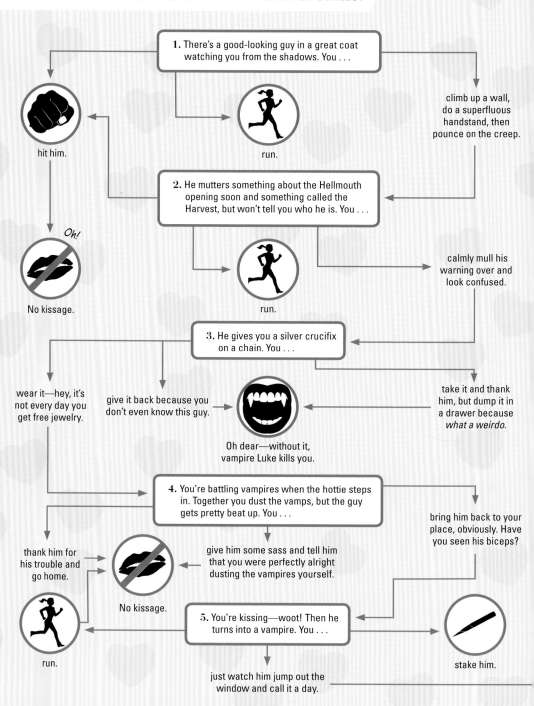

1. There's a good-looking guy in a great coat watching you from the shadows. You . . .

hit him.

run.

climb up a wall, do a superfluous handstand, then pounce on the creep.

Oh!

No kissage.

2. He mutters something about the Hellmouth opening soon and something called the Harvest, but won't tell you who he is. You . . .

run.

calmly mull his warning over and look confused.

3. He gives you a silver crucifix on a chain. You . . .

wear it—hey, it's not every day you get free jewelry.

give it back because you don't even know this guy.

take it and thank him, but dump it in a drawer because *what a weirdo*.

Oh dear—without it, vampire Luke kills you.

4. You're battling vampires when the hottie steps in. Together you dust the vamps, but the guy gets pretty beat up. You . . .

thank him for his trouble and go home.

give him some sass and tell him that you were perfectly alright dusting the vampires yourself.

bring him back to your place, obviously. Have you seen his biceps?

No kissage.

run.

5. You're kissing—woot! Then he turns into a vampire. You . . .

stake him.

just watch him jump out the window and call it a day.

60

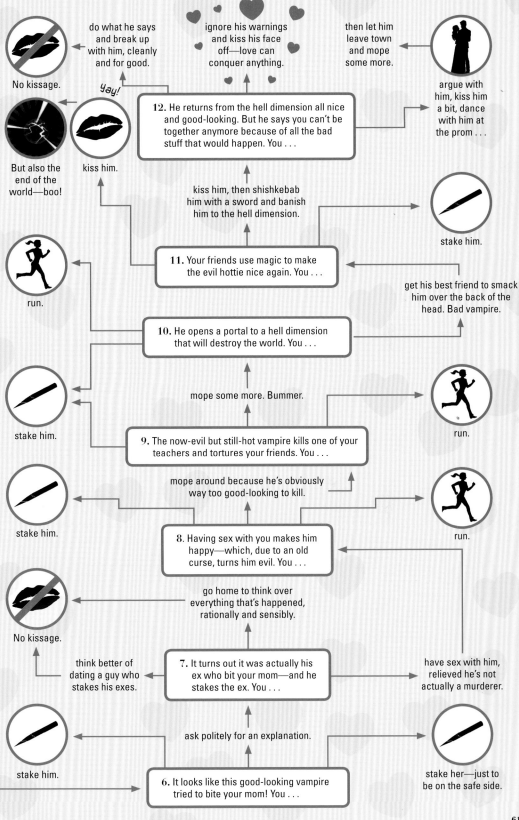

No kissage.

do what he says and break up with him, cleanly and for good.

ignore his warnings and kiss his face off—love can conquer anything.

then let him leave town and mope some more.

Yay!

But also the end of the world—boo!

kiss him.

12. He returns from the hell dimension all nice and good-looking. But he says you can't be together anymore because of all the bad stuff that would happen. You . . .

argue with him, kiss him a bit, dance with him at the prom . . .

kiss him, then shishkebab him with a sword and banish him to the hell dimension.

stake him.

run.

11. Your friends use magic to make the evil hottie nice again. You . . .

get his best friend to smack him over the back of the head. Bad vampire.

10. He opens a portal to a hell dimension that will destroy the world. You . . .

stake him.

mope some more. Bummer.

run.

stake him.

9. The now-evil but still-hot vampire kills one of your teachers and tortures your friends. You . . .

mope around because he's obviously way too good-looking to kill.

run.

stake him.

8. Having sex with you makes him happy—which, due to an old curse, turns him evil. You . . .

No kissage.

go home to think over everything that's happened, rationally and sensibly.

think better of dating a guy who stakes his exes.

7. It turns out it was actually his ex who bit your mom—and he stakes the ex. You . . .

have sex with him, relieved he's not actually a murderer.

stake him.

ask politely for an explanation.

stake her—just to be on the safe side.

6. It looks like this good-looking vampire tried to bite your mom! You . . .

JOYCE AND DAWN SUMMERS

SUMMERS WOMEN ARE TOUGH

HEIGHT
5'7"

FIRST WORDS

"Now you have a good time. I know you'll make friends right away. Think positive. And honey . . . try not to get kicked out."
1-01 Welcome to the Hellmouth

LAST WORDS

"On the dessert cart!"
5-15 I Was Made to Love You

1997

Moves to Sunnydale, where she runs an art gallery

Dates Ted Buchanan, who she later discovers is a robot

1998

Becomes besotted with Xander (due to a spell)

Has a one-night stand with Giles (due to a spell)

DAWN EPISODE COUNT

66 (46%)

LOVES

Anchovies (her favorite pizza topping)

Her sister (sometimes)

Harry Potter

HATES

Being younger than everyone else

Her sister (sometimes)

Not being "real"

TALENTS
Casting spells (a bit)
Stealing
Killing vampires

2000
"Born"

CRUSHES
Justin
Xander
Spike
RJ

2001

Discovers her true identity as "the Key"

Becomes a kleptomaniac for a short time

Is kidnapped by Glory

Has first kiss with a vampire named Justin; later dusts him

LOVES
Buffy
Dawn
Her art gallery
Passions
Thelma & Louise
Seals and Crofts
Burt Reynolds

HATES
Jell-O

58
(40%)

JOYCE EPISODE COUNT

4

Number of episodes
Joyce appears in
after she died

LOVE INTERESTS
Hank Summers (married, divorced)
Ted
Xander (love spell)
Giles (candy spell)
Dracula (coffee date)

1999
Tries to burn
Buffy (due to a
spell—again)

2000
Diagnosed
with a brain
tumor

2001
Dies of a brain
aneurysm

TALENTS
Running her art gallery
Being a mom
Caring for Buffy's friends

14
Age of Dawn
when we first
meet her

FIRST WORDS
"Mom!"
5-01 Buffy vs. Dracula

LAST WORDS
"Yeah, Buffy. What are
we gonna do now?"
7-22 Chosen

HEIGHT
5'7½"

2002
Enrolls at Sunnydale High School

Becomes the victim of a love spell cast
by a fellow student

Helps the Scooby gang defeat the First

ALIAS
The Key
"Human, now, and helpless."
The last Monk of Dagon to Buffy, in
5-05 No Place Like Home

63

FAMILY OR BLOOD TIES

BUFFY SPENDS FOUR SEASONS AS AN ONLY CHILD, BUT HOW MUCH BETTER IS A BIGGER FAMILY? WELL, IT'S RELATIVE . . .

XANDER

While Xander battles demons, his family members battle each other.

Jessica Harris	Anthony Harris		Rory Harris (Uncle)	Dave (Uncle)

Alexander Lavelle Harris

Carol Harris (Cousin)	Multiple husbands

Karen Harris

BUFFY

They're so close-knit that loss hurts all the more.

Arlene (Joyce's sister)	Joyce Summers — Hank Summers	Hank's secretary

Buffy Anne Summers | Dawn Summers | Celia (Cousin)

WILLOW

Brr, did it just get chilly in here?

Sheila Rosenberg ——— Ira Rosenberg

Willow Danielle Rosenberg

GILES

Quintessential man of mystery.

??? —— Rupert Edmund Giles —— ???

??? ???

ANGEL

Not a happy family, even
before Angel was a vampire.

Unknown —————— Unknown
killed by Angel killed by Angel

Liam Kathy
(aka Angel)

SPIKE

All we know is he's a
mommy's boy.

Anne
Pratt

William Pratt
(aka Spike)

TARA

You have no right to interfere
with Tara's blood kin.

Mrs. Mr.
Maclay Maclay

Tara Donald Beth
Maclay Maclay Maclay
 (Cousin)

THE COST OF SLAYAGE

VAMPIRES CAN ONLY ENTER YOUR HOME IF INVITED, SO HOW DOES BUFFY'S HOUSE KEEP GETTING TRASHED?

Summers residence, 1630 Revello Drive— near Hadley.*

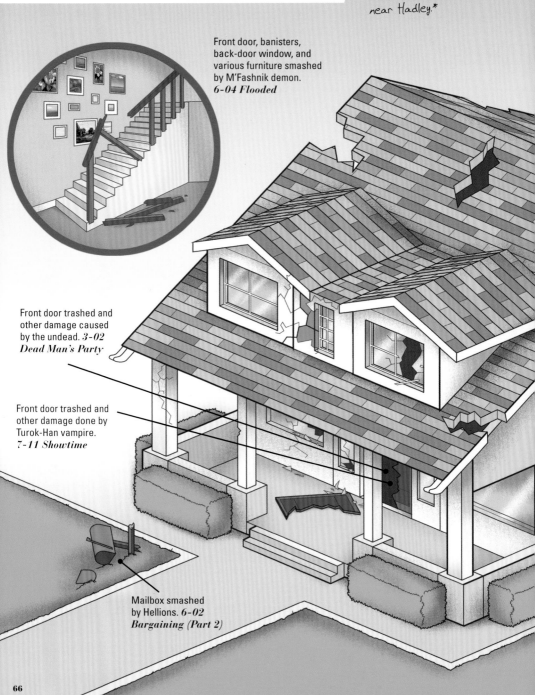

Front door, banisters, back-door window, and various furniture smashed by M'Fashnik demon. *6-04 Flooded*

Front door trashed and other damage caused by the undead. *3-02 Dead Man's Party*

Front door trashed and other damage done by Turok-Han vampire. *7-11 Showtime*

Mailbox smashed by Hellions. *6-02 Bargaining (Part 2)*

66

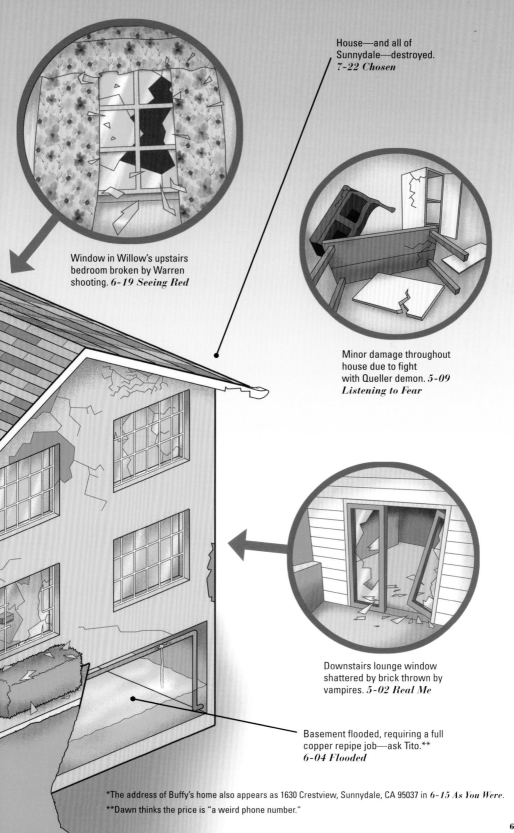

House—and all of Sunnydale—destroyed.
7-22 Chosen

Window in Willow's upstairs bedroom broken by Warren shooting. *6-19 Seeing Red*

Minor damage throughout house due to fight with Queller demon. *5-09 Listening to Fear*

Downstairs lounge window shattered by brick thrown by vampires. *5-02 Real Me*

Basement flooded, requiring a full copper repipe job—ask Tito.**
6-04 Flooded

*The address of Buffy's home also appears as 1630 Crestview, Sunnydale, CA 95037 in *6-15 As You Were*.
**Dawn thinks the price is "a weird phone number."

SADDEST MOMENTS

Sad (adj.)

1. Feeling or showing sorrow
2. Pathetic, uncool, or awkward
3. Xander, according to Cordelia

Giles discovers Jenny Calendar's body

Buffy kills Angel

Willow breaks up with Oz

Cassie Newton drops dead at Buffy's feet

Joyce's death

WEEPY

Willow tries to get her mom's attention by coming out as a witch

Buffy's sacrifice to save Dawn

Tara's death

Buffy tells Spike she loves him just as he's about to die

Buffy disowns Giles

Anya's death

Spike's addiction to soap operas

Everything about Jonathan

Wesley's hesitation in asking Cordelia for a dance

Robot
April's
death

AWKWARD

Giles sings a very emotional song at the Espresso Pump

Xander meets his own über-successful double

Angel gets jealous of Spike's soul

BIG BATTLES—
A SHARED DREAM

4-22 RESTLESS

1. Buffy, Willow, Xander, and Giles invoke the power of Sineya, the first Slayer, and use it to defeat Adam. (36:00 into *4-21 Primeval*)

2. Willow dreams of her own insecurities and is attacked by Sineya. (12:06)

3. Xander dreams of his own insecurities and has his heart ripped out by Sineya. (25:14)

4. Giles dreams of his own insecurities and is knifed in the head by Sineya. (31:05)

5. Buffy dreams of her own insecurities and is attacked by Sineya. (39:02)

6. Buffy refuses to be intimidated and saves her friends. (40:05)

KEY DATES

THE HORROR, THE HORROR

Willow dreams of having to perform on stage in front of everyone she knows. Waaah!

Xander dreams of being seduced by Joyce. Weird!

Giles dreams of singing at the Bronze. It's quite nice, really.

THE HIGH COST OF WINNING

It's all a dream—isn't it?

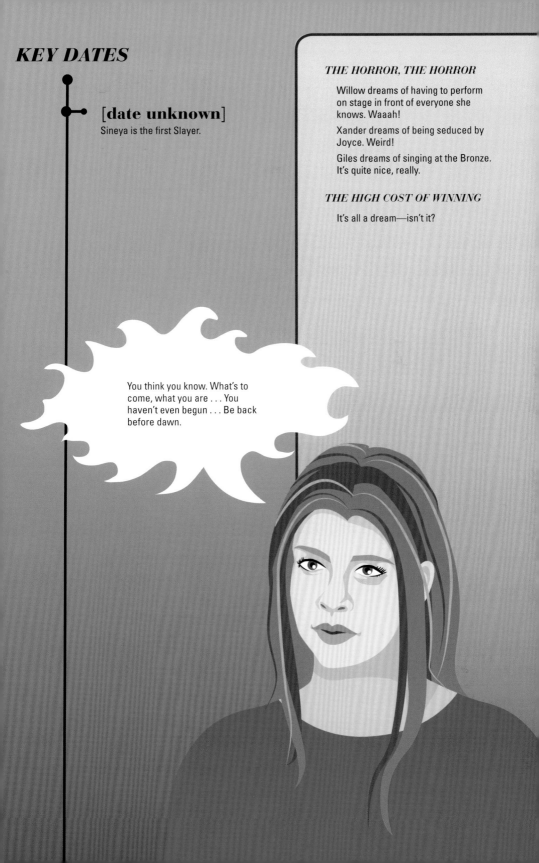

You think you know. What's to come, what you are . . . You haven't even begun . . . Be back before dawn.

SPIKE / WILLIAM

A QUICK LOOK AT THE SHOW'S ULTIMATE BAD BOY

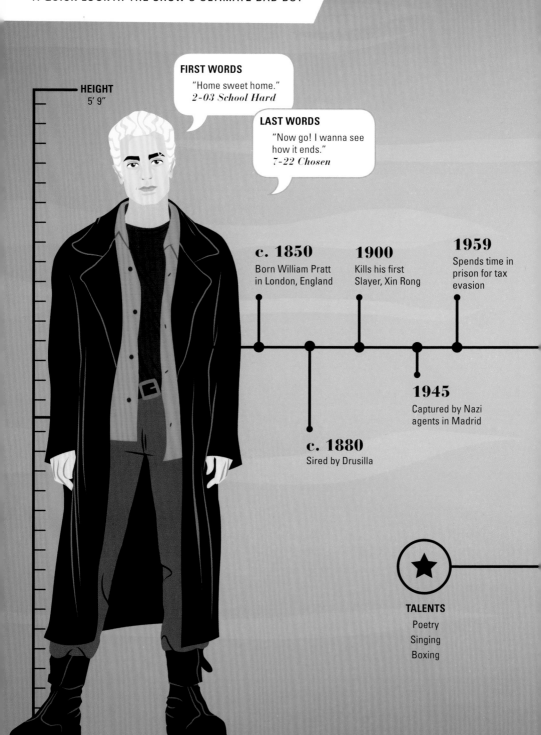

HEIGHT
5' 9"

FIRST WORDS
"Home sweet home."
2-03 School Hard

LAST WORDS
"Now go! I wanna see how it ends."
7-22 Chosen

c. 1850
Born William Pratt in London, England

1900
Kills his first Slayer, Xin Rong

1959
Spends time in prison for tax evasion

1945
Captured by Nazi agents in Madrid

c. 1880
Sired by Drusilla

TALENTS
Poetry
Singing
Boxing

LOVES
Weetabix
Punk rock
Buffy

HATES
Angel
Pipe organs
Halloween

121
(84%)

EPISODE COUNT

2003
Sacrifices himself to
destroy the Turok-Han
and close the Hellmouth

1997
Arrives in Sunnydale
after being attacked
in Prague

Is crushed by a
collapsing pipe
organ, leaving him
paralyzed

2000
Starts having
erotic dreams
about Buffy

1969
Attends
Woodstock

1963
Kills two members
of the Watchers'
Council

1977
Kills his second
Slayer, Nikki Woods

1999
Hooks up with
Sunnydale High
student–turned–
vampire Harmony
Kendall

Is captured by the
Initiative and has a
cerebral microchip
implanted in his skull

2001
Begins an
affair with
Buffy

2002
Travels to
Africa and
has his soul
returned

ROMANTIC QUESTS
Buffy
Drusilla
Buffybot
Cecily Addams

ALSO KNOWN AS
William the Bloody, after the
"bloody awful" poetry he
wrote in his lifetime

73

FOOLS FOR LOVE

THE BEST AND WORST PICK-UP LINES HEARD IN SUNNYDALE

I did a lot of thinking today. I really can't be around you. Because when I am . . . when I am, all I can ever think about is how badly I want to kiss you. (to Buffy) *1-07 Angel*

You know, Buffy, uh, Spring Fling is a time for students to gather and . . . Oh, God! Buffy, I want you to go to the dance with me. You and me, on a date. (to Buffy) *1-12 Prophecy Girl*

Sometimes when I'm sitting in class . . . you know, I'm not thinking about class, 'cause that would never happen. I think about kissing you. And it's like everything stops. It's like—it's like freeze frame. Willow kissage. (to Willow) *2-14 Innocence*

You are so cool. You're like Burt Reynolds. (to Giles) *3-06 Band Candy*

I like you. You're funny and you're nicely shaped. And frankly it's ludicrous to have these interlocking bodies and not interlock. Please remove your clothing now. (to Xander) *4-03 The Harsh Light of Day*

Parker

I've yet to find the girl that I can just sit with. Feel totally at ease. Feeling whatever's on my mind. Or even sit with comfortably in silence. Willow, can I tell you something kinda private? Just that I've enjoyed talking to you. Here. Tonight. (to Willow) *4-05 Beer Bad*

Did Willow tell you I like cheese? (to Buffy) *4-07 The Initiative*

Riley

Willow

A funny thing happened with my prior social engagement. Pretty much ended when a friend of mine went off to do something with another crowd she hangs out with. Irony is kind of ironic that way. Anyway, I know it's late, but I thought maybe, I mean, if you still wanted to do something? (to Tara) *4-13 The I in Team*

My heart expands,
'Tis grown a bulge in it,
Inspired by your beauty, effulgent.
(to Cecily) *5-07 Fool for Love*

Okay, I dig the way you always turn off the *Moulin Rouge!* DVD at Chapter 32 so it has a happy ending. I like the way you speak; it's interesting. And your freckles . . . lickable. I'm not so into the magic stuff. It seems like fairy-tale crap to me, but if it matters to you . . . You care about it, so it's cool. (to Willow) *7-13 The Killer in Me*

Spike

Kennedy

DEAD THINGS

"I MAY BE DEAD, BUT I'M STILL PRETTY."
—BUFFY, *1-12 PROPHECY GIRL*

161
DUSTINGS ON-SCREEN
= 1.12 per episode

15
EPISODES IN WHICH NO ONE DIES
1-03 Witch
1-10 Nightmares
1-11 Out of Mind, Out of Sight
2-02 Some Assembly Required
4-02 Living Conditions
4-03 The Harsh Light of Day
4-07 The Initiative
4-12 A New Man
4-22 Restless
5-17 Forever
5-18 Intervention
6-09 Smashed
6-11 Gone
7-13 The Killer in Me
7-19 Empty Places

7
SIRINGS ON-SCREEN
1-02 The Harvest—Luke sires Jesse McNally
1-05 Never Kill a Boy On a First Date—
Unnamed vampire sires Andrew Borba
2-07 Lie to Me—Spike sires Billy Fordham
2-15 Phases—Angel sires Theresa Klusmeyer
2-21 Becoming (Part 1)—Darla sires Angel
5-07 Fool for Love—Drusilla sires Spike
7-08 Sleeper—Spike sires an unnamed woman

574
DEATHS IN THE SERIES

Other deaths 240—41.81%

O

Buffy kills 212—36.93%

B

Xander kills 11.5*—2%

X

Giles kills 12—2.09%

G

Angel kills 14—2.44%

A

Willow kills 14.5*—2.53%

W

Spike kills 70—12.2%

S

*In 3–09 The Wish, Xander and Willow kill Cordelia, scoring half a kill each.

ADVERTISEMENT

MIRACULOUS CURES FOR VAMPIRISM

ARE <u>YOU</u>:

* AFFLICTED BY FANGS?
* BLIGHTED BY BLOOD-LUST?

* SUDDENLY FEELING THE IMPULSE TO RUTHLESSLY EAT YOUR LOVED ONES?

Then, you, Sir or Madame, surely suffer from **VAMPIRISM**, an ancient and respectable malady but outwith the conventional Books and Education of leading medical men. Oh, woe and again woe—the Doctors cannot help you. What are you to do? Who are you to turn to? Permit us to offer these **TRUSTED** and **PROVEN** remedies for your unfortunate condition.

THE KALDERASH CURSE

Developed by Kalderash gypsies in Romania, this highly potent magic was used to full and evident effect in 1898 on the infamous vampire Angelus, restoring his soul.

The patented method uses an **Orb of Thesulah**—a spirit vault for the Rituals of the Undead.

Nici mort nici al fiintei te invoc, spirit al trécerii. Reda trupului ce separa omul de animal. Asa sa fie.

Not dead, nor of the living. Spirits of the interregnum, I call. Restore to the corporal vessel that which separates us from beast. So shall it be.

Warning: A moment of pure happiness such as "full intimacy" with another Person may render a premature end to this curse. We can take no responsibility for any resultant maiming, torture, or embarrassment.

AFRICAN TRIALS

This Adventurous Excursion is not for the faint-hearted, but promises a full cure. Simply complete a series of tasks for a discretely unnamed demon in a cave in Uganda and your soul will be returned. The trials include:

* Fight to death with a man whose hands are on fire
* Fight to death with at least two other demons
* Endure a plague of insects and beetles in your nose and mouth

Do please note that these trials—and the trip to sunny Africa—have a high risk of death or permanent injury. The return of your soul may lead to madness, and we cannot vouchsafe that it will mean any person will now reciprocate any amatory feelings.

LETHE'S BRAMBLE

A remarkable remedy with none of the Inherent Dangers of other so-called cures! Simply FORGET that you're a vampire!!!

e Press

Thursday, January 19, 1899

QUICK! SIMPLE! EFFECTIVE!

Lethe's Bramble is a Natural and Organic herb.

The preparation: Dry the sprigs, burn them, and then touch them with the white crystal WE will supply, while reciting this easily remembered incantation:

Let Lethe's Bramble do its chore. Purge their minds of memories grim, of pains from recent slights and sins . . .

When the fire goes out. When the crystal turns black. The spell will be cast.

Tabula rasa. Tabula rasa. Tabula rasa.

The crystal will turn GRAY on contact with the herbs, and BLACK when the enchantment has worked.

BOTTLE IT

Cheap, effective alternative to biting people. Available from all over-worked hospitals where security is a bit lax.

STAKE

Cure your vampirism the traditional way! <u>Heartily</u> endorsed by the Watchers' Council of Britain.

HOLIDAY

If you're not minded to CURE your condition, perhaps you just want a change of scene. Sorcerer **Richard Wilkins** has newly established the town of Sunnydale in California with convenient views of the Hellmouth.

STOP VAMPIRES WITH CHIPS

FAO all agents: Professor Walsh reports positive results from the first deployed use of the BEHAVIOR-MODIFICATION CIRCUITRY on a Hostile Subterranean. When the "chip" was surgically implanted onto the brain of Hostile 17, any attempt at violence directed at a human caused Hostile 17 severe neurological pain.

The chip does not affect HSTs in conflict with other HSTs, which may mean treated subjects can be conditioned for work on dangerous operations. Professor Walsh estimates that, from implantation, each chip will operate for two years before terminating the subject. "Frankly, there's no downside," says Walsh. "It's another proof of concept as we work towards realization of the 314 Project."

TOP SECRET
INITIATIVES EYES ONLY

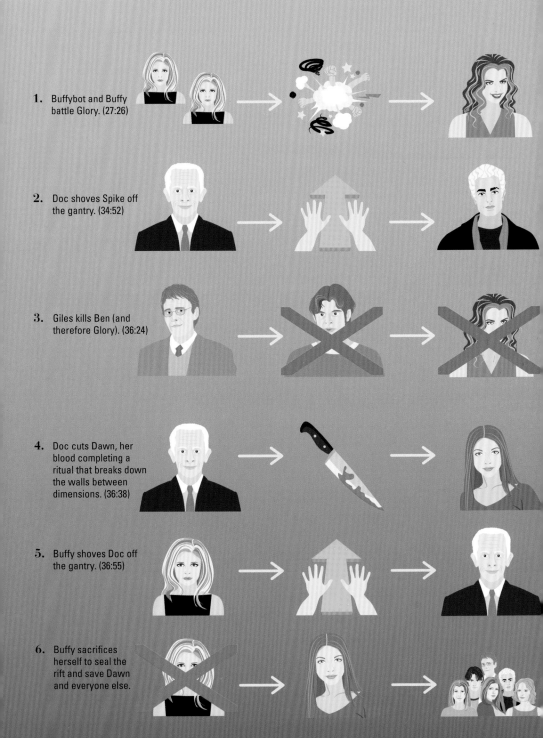

1. Buffybot and Buffy battle Glory. (27:26)

2. Doc shoves Spike off the gantry. (34:52)

3. Giles kills Ben (and therefore Glory). (36:24)

4. Doc cuts Dawn, her blood completing a ritual that breaks down the walls between dimensions. (36:38)

5. Buffy shoves Doc off the gantry. (36:55)

6. Buffy sacrifices herself to seal the rift and save Dawn and everyone else.

KEY DATES

[date unknown]
Glorificus rules a hell dimension with two other hellgods, who become afraid of her growing power and cruelty. A battle erupts between them.

c. 1976
The hellgods banish Glorificus to Earth, where she is forced to live and die in the body of newborn Ben Wilkinson.

2000
Monks of the Order of Dragon find the Key of living energy that can shatter the walls between dimensions, allowing Glory to get home. To hide the Key, the monks turn it into a sister for Buffy—Dawn.

2001
Glory finds Dawn.

> Once the key is activated, it won't just open the gates to the beast's dimension. It's going to open all the gates. The walls separating realities will crumble. Dimensions will bleed into each other. Order will be overthrown and the universe will tumble into chaos. All dark, forever.

THE HORROR, THE HORROR
Dawn is cut and bled to open the rift
Spike is thrown from the gantry

THE HIGH COST OF WINNING
Giles kills the innocent Ben
Bricks fall on Anya
Buffy dies

> Sooner or later Glory will reemerge and make Buffy pay for that mercy. And the world with her. Buffy even knows that and still she couldn't take a human life. She's a hero, you see. She's not like us.

DANIEL "OZ" OSBOURNE AND CORDELIA CHASE

THE COOLEST WEREWOLF AND THE ULTIMATE QUEEN BEE

HEIGHT
5'4"

FIRST WORDS
"Of what?"
2-04 Inca Mummy Girl

LAST WORDS
"Pretty much now."
4-19 New Moon Rising

DINGOES ATE MY BABY
A favorite act at the Bronze
Singer: Devon MacLeish
Guitar: Daniel "Oz" Osbourne

66 There's a quiet restraint and total lack of bitterness to [Oz's] sarcasm; where Devon is your typical excitable rock and roller, Oz is completely unflappable. His is the kind of cool that is completely unaware of itself. 99

Description of Oz in the script for *2-04 Inca Mummy Girl*

CORDELIA EPISODE COUNT

56
(39%)

LOVES
Whitney Houston
Attention
Money

HATES
Nerds
Libraries
Tact

LOVE CHART

Jesse McNally
Guy Matthews
John Lee Walker
Richard Anderson
Owen Thurman
Mitch Fargo
Wesley Wyndam-Pryce
Angel
Kevin Benedict
Xander Harris

THE CORDETTES
Cordelia's popular clique
Harmony Kendall
Gwen Ditchik
Aura
Aphrodesia

1997
Meets and initially befriends Buffy
Runs for May Queen
Kidnapped by Sunnydale student Chris Epps
Nearly sacrificed to the demon Machida
Kisses Xander for the first time

LOVES
Sleep
(when he can get it)
Willow
Music

HATES
Talking
Tara
Full moons

40
(28%)

OZ EPISODE COUNT

TALENTS
Playing guitar
Powerful sense of smell
Quiet sarcasm

4
Nights
per month
that Oz
spends as a
werewolf

1997
First sees Willow
(dressed as an
Eskimo at the Bronze)

Starts dating Willow

1998
Discovers he has
become a werewolf
after being bitten by
his cousin

Breaks up with Willow
after seeing her kiss
Xander

Gets back together
with Willow

1999
Enrolls at UC
Sunnydale as a
psychology student

Willow discovers he
has cheated on her
with Veruca, a fellow
werewolf

Kills Veruca after
she threatens to kill
Willow

Leaves Sunnydale

2000
Returns to Sunnydale
from Tibet and is
captured by the
Initiative

After being rescued by
Buffy and Riley, leaves
Sunnydale again

TALENTS
Cheerleading
Color coordination
Makeup

FIRST WORDS
"Here."
1-01 Welcome to the Hellmouth

LAST WORDS
"I'm for it."
*3-21 Graduation
Day (Part 1)*

HEIGHT
5'7"

1998
Temporarily ends her affair with Xander
on Valentine's Day

After witnessing Xander and Willow
kiss, falls and impales herself

Breaks up with Xander once and for all

Wishes that Buffy had never come to
Sunnydale and gets her wish granted by
the demon Anyanka

1999
Begins working at the April Fools
boutique

Is (badly) kissed twice by Wesley
Wyndam-Pryce

Stakes her first vampire

Moves to Los Angeles after graduation
to pursue an acting career

UNEXPECTED WISDOM

MANY IN THE SHOW ARE KNOWN FOR THEIR QUIPPY ELOQUENCE, BUT OZ AND CORDELIA REALLY DO DELIVER SOME OF THE PITHIEST, WITTIEST, SASSIEST LINES

I miss you . . . like, every second. It's like I lost an arm, or worse, a torso. *3-10 Amends*

I am my thoughts. If they exist in her, Buffy contains everything that is me, and she becomes me. I cease to exist. *3-18 Earshot*

That's great, Larry. You've really mastered the single entendre. *2-15 Phases*

Other bands know more than three chords. Your professional bands can play up to six, sometimes seven completely different chords. *3-16 Doppelgangland*

This warlock in Romania sent me to the monks there to learn some meditation techniques. Very intense. All about keeping your inner cool. *4-19 New Moon Rising*

Mom started borrowing my clothes. There should be an age limit on Lycra pants. *3-06 Band Candy*

Look, Buffy, you may be hot stuff when it comes to demonology or whatever, but when it comes to dating, I'm the Slayer. *2-06 Halloween*

I aspire to help my fellow man. Check. As long as he's not smelly, dirty, or something gross. *2-09 What's My Line (Part 1)*

Do you know what you need, Xander, besides a year's supply of acne cream? A brain. *2-08 The Dark Age*

Planning life as a loser? Most people just turn out that way, but you're really taking charge. *3-14 Bad Girls*

BANDS AT THE BRONZE

THE BRONZE IS THE ONLY CLUB IN SUNNYDALE WORTH GOING TO; EVEN IF THEY LET ANYBODY IN THERE, IT'S STILL THE SCENE. BUT WHO'S PLAYING?

T
BRO

NERF HERDER	DARLING VIOLETTA
DASHBOARD PROPHETS	SPLENDID
SHY	CIBO MATTO
DINGOES ATE MY BABY	MICHELLE BRANCH
AIMEE MANN	THE BREEDERS

"Man, I hate playing vampire towns!"
—Aimee Mann at the Bronze, *7-08 Sleeper*

NZE

ABERDEEN	LOTION
BELLYLOVE	NICKEL
VELVET CHAIN	SPRUNG MONKEY
DEVICS	VIRGIL
HALO FRIENDLIES	SUPERFINE
ANGIE HART	

BUFFY: THE ALBUM JUKEBOX

BUFFY THE VAMPIRE SLAYER: THE ALBUM WAS RELEASED BY TVT RECORDS ON OCTOBER 19, 1999

Buffy the Vampire Slayer Theme Nerf Herder	**1**	**10**	**Already Met You** Superfine
Teenage FBI Guided by Voices	**2**	**11**	**The Devil You Know (God is a Man)** Face to Face
Temptation Waits Garbage	**3**	**12**	**Nothing But You** Kim Ferron
Strong Velvet Chain	**4**	**13**	**It Doesn't Matter** Alison Krauss & Union Station
I Quit Hepburn	**5**	**14**	**Wild Horses** The Sundays
Over My Head Furslid	**6**	**15**	**Pain (Slayer Mix)** Four Star Mary
Lucky Bif Naked	**7**	**16**	**Charge** Splendid
Keep Myself Awake Black Lab	**8**	**17**	**Transylvanian Concubine** Rasputina
Virgin State of Mind K's Choice	**9**	**18**	**Close Your Eyes (Buffy/Angel Love Theme)** Christophe Beck

A B C D E F G H J K

1 2 3 4 5 6 7 8 9 10

INSERT COIN PRESS THE RED BUTTON

1. Buffy the Vampire Slayer Theme
Nerf Herder

Featured in the opening credits of the show

Nerf Herder was formed in 1994. The band's name comes from a line from *The Empire Strikes Back*.

2. Teenage FBI
Guided by Voices

Not featured in the show

This song is included in the album *Do the Collapse*, released on August 3, 1999. Guided by Voices was formed in 1983, and its only founding member still in the band is singer-songwriter Robert Pollard.

3. Temptation Waits
Garbage

Not featured in the show

The song is from the album *Version 2.0*, released May 4, 1998. Garbage is also known for its James Bond theme *The World Is Not Enough*.

4. Strong
Velvet Chain

Featured in *1-05 Never Kill a Boy on the First Date*

This song is from the album *Warm*, released in December 1997.

5. I Quit
Hepburn

Not featured in the show

I Quit appears in the album *Hepburn*, released on August 30, 1999.

6. Over My Head
Furslide

Not featured in the show

The song is from the album *Adventure*, released on October 6, 1998. It was the band's only LP.

7. Lucky
Bif Naked

Featured in *4-03 The Harsh Light of Day*

The song is from the album *I Bificus*, released on February 24, 1998. Bif Naked is the nom-de-plume of Canadian singer-songwriter Beth Torbert.

8. Keep Myself Awake
Black Lab

Featured in *4-13 The I in Team*

Black Lab was formed in 1995 and is still active.

9. Virgin State of Mind
K's Choice

Featured in *4-16 Doppelgangland*

K's Choice is a Belgian rock band from Antwerp.

10. Already Met You
Superfine

Featured in *1-04 Teacher's Pet*

Already Met You appears in the EP *Superfine*.

11. The Devil You Know (God Is a Man)
Face to Face

Featured in *4-18 Where the Wild Things Are*

The song is from the album *Ignorance Is Bliss*, released on July 27, 1999.

12. Nothing But You
Kim Ferron

Featured in *4-05 Beer Bad*

The song was first released on *Buffy the Vampire Slayer: The Album*.

13. It Doesn't Matter
Alison Krauss & Union Station

Featured in *2-01 When She Was Bad*

The song appears in the album *So Long So Wrong*, released on March 25, 1997, winner of the Grammy Award for Best Bluegrass Album.

14. Wild Horses
The Sundays

Featured in *3-20 The Prom*

This cover of The Rolling Stones song was the B-side to The Sundays' 1992 single *Goodbye*.

15. Pain (Slayer Mix)
Four Star Mary

Featured in *2-16 Bewitched, Bothered and Bewildered*

Pain was released as a single in 2001. Three members of Four Star Mary are members of fictitious Buffy band Dingoes Ate My Baby.

16. Charge
Splendid

Featured in *2-19 I Only Have Eyes for You*

Splendid consisted of a married couple, Angie Hart and Jesse Tobias.

17. Transylvanian Concubine
Rasputina

Featured in *2-13 Surprise*

This song is from the EP *Transylvanian Regurgitations*, released on August 12, 1997.

18. Close Your Eyes
(Buffy/Angel Love Theme)
Christophe Beck

Featured in several episodes

The Canadian-born composer Christophe Beck won an Emmy in 1998 for his work on *Buffy the Vampire Slayer*.

Other albums based on the show:

Buffy the Vampire Slayer: Once More, with Feeling
(released by Rounder Records on September 24, 2002)

Buffy the Vampire Slayer: Radio Sunnydale—Music from the TV Series
(released by Virgin Records on September 30, 2003)

Buffy the Vampire Slayer: The Score
(released by Rounder Records on September 9, 2008)

TARA MACLAY

**AT ONCE POWERFUL AND VULNERABLE,
HER CHARMS ARE LIKE NO OTHER**

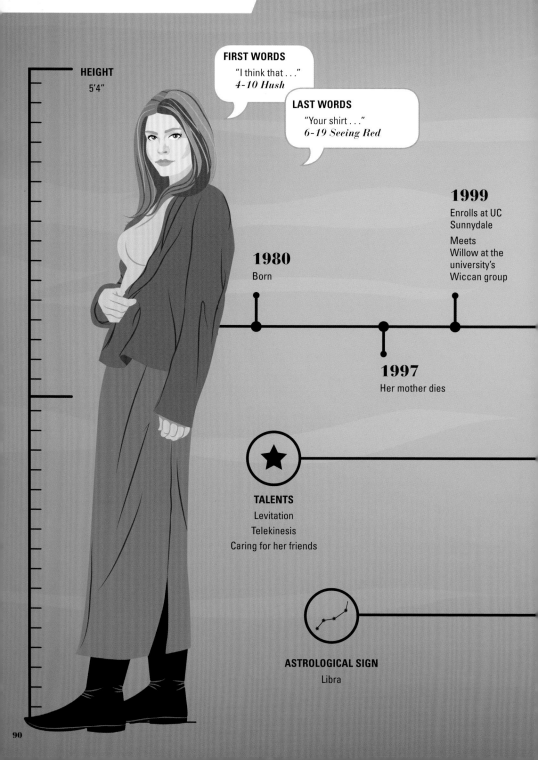

HEIGHT
5'4"

FIRST WORDS
"I think that . . ."
4-10 Hush

LAST WORDS
"Your shirt . . ."
6-19 Seeing Red

1999
Enrolls at UC
Sunnydale

Meets
Willow at the
university's
Wiccan group

1980
Born

1997
Her mother dies

TALENTS
Levitation
Telekinesis
Caring for her friends

ASTROLOGICAL SIGN
Libra

LOVES

Willow

Long skirts

Miss Kitty Fantastico

HATES

Shrimp (she's allergic)

People messing
with her memory

Being the center
of attention

47
(33%)

EPISODE COUNT

TARA
MACLAY

2001

Becomes mentally
unstable when Glory
feeds on her mind

Ends her relationship
with Willow

2002

Gets back together
with Willow

Is shot and killed by
Warren Mears

Tara Maclay was
voted number

15

in AfterEllen.com's
"Top 50 Lesbian and
Bisexual Characters"
poll in 2010.

2000

Tara's family arrives to tell
her she must become a
demon (like her mother),
but she stands up to them

AMY VS. WILLOW VS. TARA

WHICH WITCH IS WHICH?

	AMY MADISON	WILLOW ROSENBERG	TARA MACLAY
	* WHEN WILLOW FIRST MEETS AMY, AMY IS THE FAR MORE POWERFUL WITCH!		* WHEN WILLOW FIRST MEETS TARA, TARA IS THE FAR MORE POWERFUL WITCH!
DESCENDED FROM LINE OF WITCHES	✓		✓
SUNNYDALE HIGH	✓	✓	
UC SUNNYDALE		✓	✓
DOES DARK MAGIC	✓	✓	
KILLS SOMEONE		✓	✓
KILLS SOMEONE WITH MAGIC		✓	
MOST EFFECTIVE SPELL	ESCAPES BEING BURNED AT THE STAKE BY TURNING HERSELF INTO A RAT. (3-11 GINGERBREAD) *The spell works so well she remains a rat for three years (bar one brief reprieve).*	SHE RETURNS ANGEL'S SOUL, BRINGS BUFFY BACK FROM THE DEAD, AND ALMOST DESTROYS THE WHOLE WORLD. BUT WILLOW'S GREATEST MAGIC IS WHEN SHE USES THE ESSENCE OF THE M? SCYTHE TO MAKE EVERY POTENTIAL SLAYER IN THE WORLD INTO A FULLY FLEDGED SLAYER. (7-22 CHOSEN)	THE FIRST TIME SHE MEETS BUFFY, SHE SPOTS THAT THE FLOW OF HER ENERGY IS FRAGMENTED—BECAUSE FAITH HAS SWAPPED BODIES WITH HER. WILLOW AND TARA THEN CONJURE A DRACONIAN KATRA TO SWAP BUFFY AND FAITH BACK. (4-16 WHO ARE YOU?)
SAY WHAT?	"GODDESS HECATE, WORK THY WILL! BEFORE THEE LET THE UNCLEAN THING CRAWL!" (AMY TURNS HERSELF INTO A RAT, 3-11 GINGERBREAD)	"TE IMPLOR DOAMNE, NU IGNORA ACCASTA RUGAMINTE! LASA ORBITA SA FIE VASUL CARE—I VA TRANSPORTA SUFLETUL LA EL! ESTE SCRIS, ACEASTA PUTERE ESTE DREPTUL POPORUII MEU DE A CONDUCE. . . ASA SA FIE! ACUM!" (WILLOW RETURNS ANGEL'S SOUL TO HIM, 2-22 BECOMING, PART 2)	"BLIND CADRIA, DESOLATE QUEEN, WORK MY WILL UPON THEM ALL, YOUR CURSE UPON THEM, MY OBEISANCE TO YOU." (TARA MAKES DEMONS INVISIBLE TO HER FRIENDS, 5-06 FAMILY)
LEAST EFFECTIVE SPELL	A LOVE SPELL INTENDED TO MAKE CORDELIA FALL FOR XANDER MAKES ALL WOMEN EXCEPT CORDELIA FALL FOR XANDER. (2-16 BEWITCHED, BOTHERED AND BEWILDERED)	MAGICALLY CONTROLS A CAR SHE AND DAWN ARE IN AS THEY ARE CHASED BY A DEMON—ONLY TO SMASH THE CAR INTO A PILLAR, FRACTURING DAWN'S ARM AND ALMOST KILLING THEM BOTH. (6-10 WRECKED)	SO WILLOW AND THE OTHERS DON'T FIND OUT THAT TARA IS A DEMON, SHE CASTS A SPELL THAT MAKES DEMONS INVISIBLE TO THEM—WHICH IS NO HELP WHEN DEMONS THEN ATTACK. ANYWAY, TARA ISN'T A DEMON. (5-06 FAMILY)

FINAL VERDICT

AMY AND TARA ARE BOTH GIFTED WITCHES, BUT WILLOW . . .
SHE'S A GODDESS (AS KENNEDY SAYS IN 7-22 CHOSEN).

ROOKIES?

THE OTHER SCOOBIES AND THEIR SKILLS AT MAGIC

GILES CALLS ON CORSHETH AND GILAIL TO REVERSE THE SPELL CAST BY AMY'S MOM CATHERINE; HE SAYS IT'S HIS FIRST CASTING. (1-03 WITCH)

SPIKE USES ANGEL'S BLOOD IN A RITUAL OF BLACK MEDICINE TO HEAL DRUSILLA. (2-10 WHAT'S MY LINE, PART 2)

ANGEL EASILY TRANSFORMS A FIRE INTO THE FLAME OF LIFE. (3-07 REVELATIONS)

ANYA (WITH WILLOW'S HELP) CALLS ON ERYISHON TO RETRIEVE HER MAGIC AMULET FROM ANOTHER DIMENSION, BUT RETRIEVES A VAMPIRE WILLOW INSTEAD. (3-16 DOPPELGANGLAND)

OZ INADVERTENTLY SUMMONS THE DEMON GACHNAR BY BLEEDING ON A MAGIC SYMBOL. (4-04 FEAR, ITSELF)

JONATHAN'S AUGMENTATION SPELL MAKES PEOPLE THINK HE'S ONE OF THE GANG AND A HERO. (4-17 SUPERSTAR)

BUFFY PERFORMS CLOUTIER'S "TIRER LA COUVERTURE," A SPELL TO SEE SPELLS, AND SO LEARNS THAT DAWN IS NOT HER SISTER. (5-05 NO PLACE LIKE HOME)

DAWN CASTS A RESURRECTION SPELL THAT BRIEFLY BRINGS HER MOTHER BACK TO LIFE. (5-17 FOREVER)

XANDER SUMMONS AN UNNAMED DEMON WHO MAKES EVERYONE IN SUNNYDALE SING AND DANCE. (6-07 ONCE MORE, WITH FEELING)

THERE AND BACK AGAIN

DEATHS AND REBIRTHS IN SUNNYDALE

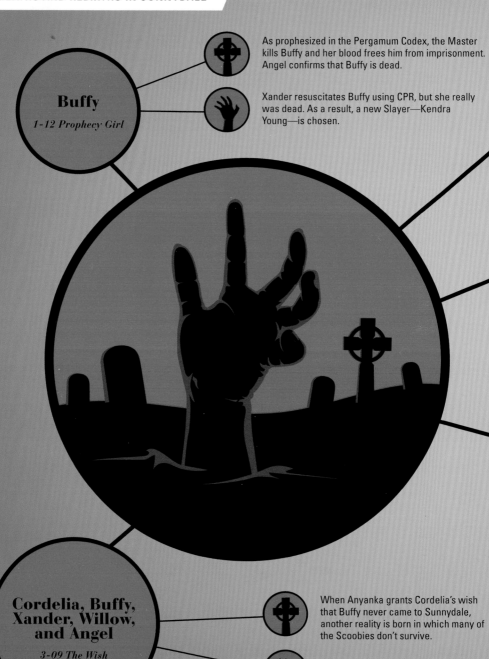

Buffy

1-12 Prophecy Girl

As prophesized in the Pergamum Codex, the Master kills Buffy and her blood frees him from imprisonment. Angel confirms that Buffy is dead.

Xander resuscitates Buffy using CPR, but she really was dead. As a result, a new Slayer—Kendra Young—is chosen.

Cordelia, Buffy, Xander, Willow, and Angel

3-09 The Wish

When Anyanka grants Cordelia's wish that Buffy never came to Sunnydale, another reality is born in which many of the Scoobies don't survive.

Giles breaks Anyanka's amulet, returning things to normal.

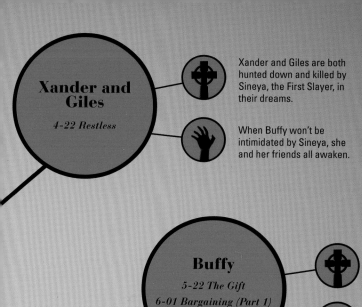

Xander and Giles
4-22 Restless

Xander and Giles are both hunted down and killed by Sineya, the First Slayer, in their dreams.

When Buffy won't be intimidated by Sineya, she and her friends all awaken.

Buffy
5-22 The Gift
6-01 Bargaining (Part 1)

Buffy dies to seal the dimensional rift, saving Dawn and her friends.

Some five months later, Willow uses dark magic and the Urn of Osiris to rip Buffy from heaven and return her to Earth.

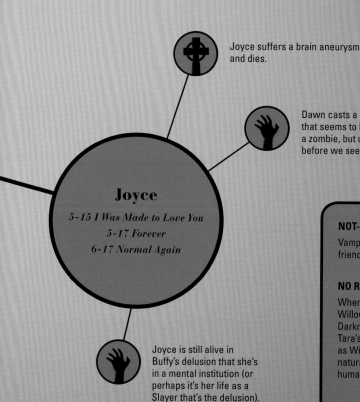

Joyce suffers a brain aneurysm and dies.

Dawn casts a resurrection spell that seems to bring Joyce back as a zombie, but undoes the spell just before we see.

Joyce
5-15 I Was Made to Love You
5-17 Forever
6-17 Normal Again

Joyce is still alive in Buffy's delusion that she's in a mental institution (or perhaps it's her life as a Slayer that's the delusion).

NOT-REALLY-HAPPY RETURNS
Vampire Jack O'Toole resurrects his dead friends as zombies in *3-13 The Zeppo*.

NO RETURNS
When her beloved Tara is murdered, Willow invokes Osiris, Keeper of Darkness, and demands the return of Tara's life. But even a witch as powerful as Willow cannot violate the laws of natural passing—a human death by human means. *(6-20 Villains)*

UC SUNNYDALE

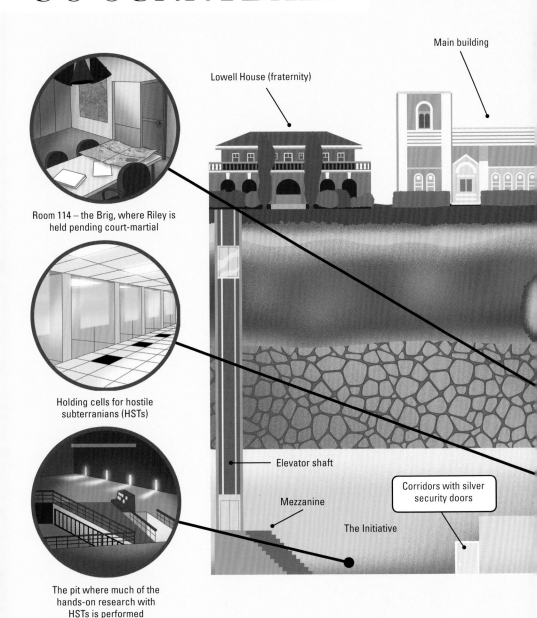

Room 114 – the Brig, where Riley is held pending court-martial

Holding cells for hostile subterranians (HSTs)

The pit where much of the hands-on research with HSTs is performed

Lowell House (fraternity)

Main building

Elevator shaft

Mezzanine

The Initiative

Corridors with silver security doors

1868
The University of California is founded and based in Oakland.

1873
The UC Berkeley campus is established.

c. 1961
UC Sunnydale is established.

Lowell Home for Children is taken over by the university for use as a fraternity house.

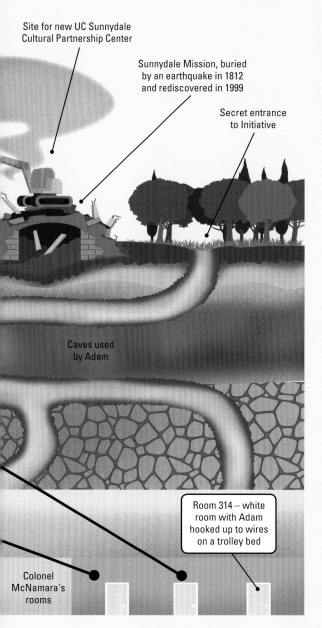

Site for new UC Sunnydale Cultural Partnership Center

Sunnydale Mission, buried by an earthquake in 1812 and rediscovered in 1999

Secret entrance to Initiative

Caves used by Adam

Room 314 — white room with Adam hooked up to wires on a trolley bed

Colonel McNamara's rooms

STAFF

(in alphabetical order)

Surrinda Blackmaster
Assistant to Dean Guerrero
Not seen, but rejects Buffy's application
to be readmitted in *6-15 As You Were*

Riley Finn
Teaching Assistant to Professor Walsh
(see below)
First seen in *4-01 The Freshman*

Professor Gerhardt
Anthropology teacher
Murdered by ghost of the Hus, *4-08 Pangs*

Matthew Guerrero
Dean of UC Sunnydale
Seen in *4-08 Pangs*

Professor Hawkins*
Seen in *7-05 Selfless*

Professor Lillian
Poetry teacher
Seen in *5-19 Tough Love*

Mike
Sociology teacher
Seen in *6-05 Life Serial*

Professor Riegert
Popular American culture teacher
Seen in *4-01 The Freshman*

Professor Roberts*
History teacher
Seen in *5-12 Checkpoint*

Professor Maggie Walsh
Psychology teacher
First seen in *4-01 The Freshman*
Murdered by Adam (her own creation)
in *4-13 The I in Team*

*Named in the shooting script, but not on-screen.

2002
A Grimslaw demon rips the hearts from all the members of an unnamed fraternity at the behest of vengeance demon Anyanka, working on behalf of a student named Rachel.

2003
The UC Sunnydale campus is destroyed along with the rest of Sunnydale.

2000
The government-sponsored Initiative, operating underneath the campus, is closed down.

1999–2001
Buffy Summers attends UC Sunnydale.

BIG BATTLES— DARK WILLOW

6-22 GRAVE

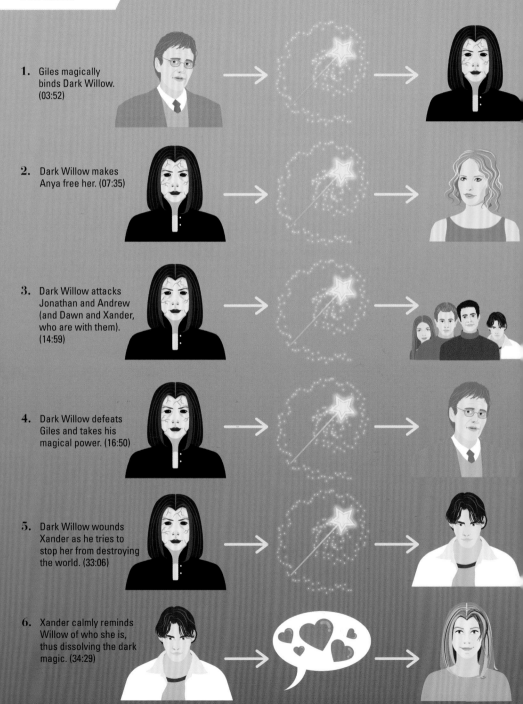

1. Giles magically binds Dark Willow. (03:52)

2. Dark Willow makes Anya free her. (07:35)

3. Dark Willow attacks Jonathan and Andrew (and Dawn and Xander, who are with them). (14:59)

4. Dark Willow defeats Giles and takes his magical power. (16:50)

5. Dark Willow wounds Xander as he tries to stop her from destroying the world. (33:06)

6. Xander calmly reminds Willow of who she is, thus dissolving the dark magic. (34:29)

KEY DATES

1932

An earthquake swallows the satanic temple on Kingman's Bluff, dedicated to the demon Proserpexa.

2002

Tara Maclay is murdered. As a result of her grief, Willow turns to the dark side.

Glory finds Dawn.

THE HORROR, THE HORROR

Prior to the final battle, Willow has already hunted down, tortured, and skinned Warren

She lashes out at her friends, the police, and anyone else in her way

She inflicts wounds on Xander

THE HIGH COST OF WINNING

Giles almost dies using the coven's magic to battle against Dark Willow

She's going to drain the planet's life force and funnel its energy through Proserpexa's effigy and burn the Earth to a cinder.

FAITH LEHANE AND ANYA JENKINS

TWO KICKASS WOMEN, AT A GLANCE

TALENTS
Sex appeal
Fighting
Being BAD

HEIGHT
5'5"

FIRST WORDS
"S'okay, I got it.
You're Buffy, right?"
3-03 Faith, Hope & Trick

LAST WORDS
"Yeah, you're not the one
and only Chosen anymore.
Just gotta live like a person.
How's that feel?"
7-22 Chosen

ARM TATTOO

1998
Becomes the Slayer as a
result of Kendra Young's
death

Arrives in Sunnydale

1999
Accidentally kills Deputy Mayor Allan Finch

Forms an alliance with Mayor Richard
Wilkins III

Murders a Sunnydale High geology professor

After Faith nearly kills Angel, Buffy stabs her
and leaves her in a coma

ANYA EPISODE COUNT

85
(59%)

LOVES
Xander
Sex
Capitalism

HATES
Rabbits
Rabbits
Rabbits

860
Born "Aud"
in Sjornjost

PERSONALITY CHART

NOSTALGIC (FOR HER DAYS AS A DEMON)
15%

BLUNT
40%

LUSTFUL
45%

880
Falls in love with
Olaf, a Viking
warrior

880/881
Is turned into a
vengeance demon
named Anyanka by
D'Hoffryn

LOVES
Partying
Drinking
Having fun with guys

HATES
Pink
Being vulnerable
Dresses

20
(14%)

FAITH EPISODE COUNT

SOCIAL CIRCLE

FRIENDS
Mayor Wilkins

LOVERS
Xander Harris
Robin Wood

ENEMIES
Buffy Summers
Willow Rosenberg
Cordelia Chase
Rupert Giles
Angel
Spike
Anya Jenkins
Joyce Summers

2000
Reawakens from her coma

Switches bodies with Buffy with the help of a Draconian Katra

NICKNAMES
1 - The Rogue Slayer
2 - Slut-o-rama
3 - Miss Attention Span

2003
Returns to Sunnydale and reconciles with Buffy

Is chosen as the leader of the potential Slayers

TALENTS
Shopkeeping
Teleportation
Brutal honesty

BIRTHPLACE
Sweden

FIRST WORDS
"Nice bag. Prada?"
3-09 The Wish

LAST WORDS
"Bunnies! Floppy, hoppy bunnies."
7-22 Chosen

HEIGHT
5'3½"

1692
Attends the Salem witch trials

2001
Gets engaged to Xander

2003
Is nearly sliced in two by a Bringer's sword and dies

1579
Meets Count Dracula

1998
Arrives in Sunnydale

Grants Cordelia's wish that Buffy had never come to Sunnydale

Giles destroys her necklace, making her mortal again

1999
Asks Xander to the school prom

2002
Xander leaves her at the altar, leading to the return of D'Hoffryn, who turns her into a vengeance demon once again

Has sex with Spike

Is stripped of her vengeance demon powers by D'Hoffryn

WANTED

POLICE DEPARTMENT OFFICIAL NOTICE

SUNNYDALE, CALIFORNIA

FAITH LEHANE

WANTED

FOR QUESTIONING CONCERNING

- criminal collusion with Mayor Richard Wilkins
- the murder of Deputy Mayor Allan Finch
- the attempted murder of a man known only as Angel
- body-switching
- kidnapping
- battery
- and other acts against the peace and dignity of Sunnydale.

 By order of the State of California Police

SPIKE
WANTED

DEAD OR **REALLY** DEAD
FOR A NUMBER OF CRIMES,
INCLUDING

- the massacre of the Kalderash Clan
- the murder of two Slayers
- the slaughter of an orphanage
- the murder of two honorable members of the Watchers' Council
- the kidnapping of Willow Rosenberg and Xander Harris

 By order of the State of California Police

DARLA AND DRUSILLA

SAY HELLO TO THE FEMALE HALF OF THE DREADED WHIRLWIND

TALENTS
Seduction
Changing hairstyles
Being a good servant

HEIGHT
5'7"

FIRST WORDS
"Are you sure this is a good idea?"
1-01 Welcome to the Hellmouth

LAST WORDS
"Angel?"
1-07 Angel

1753
Sires Angel in Galway, Ireland

Late 16th century
Born in the British Isles

1609
Sired by the Master

DRUSILLA EPISODE COUNT **17** (12%)

LOVES
Dolls
Plants
Torture

HATES
Red roses
Science
Acting like a grown-up

FASHION STYLE
1990s HEROINE CHIC 50%
VICTORIAN COURTESAN 50%

PERSONALITY CHART
IMMATURE 20%
PSYCHOTIC 80%

c. 1830
Born in the East End of London

1860s
Sired by Angelus

1860
Meets Angelus and Darla
Angelus murders her family

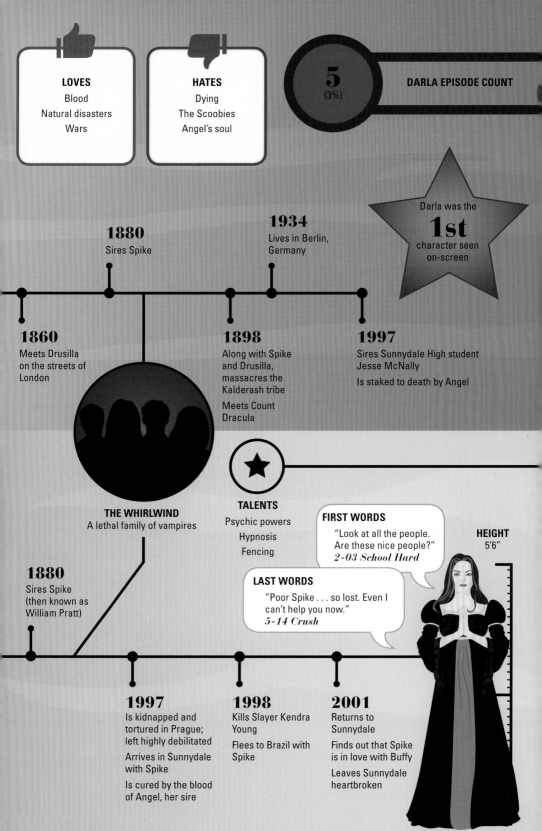

LOVES
Blood
Natural disasters
Wars

HATES
Dying
The Scoobies
Angel's soul

5
(3%)
DARLA EPISODE COUNT

Darla was the
1st
character seen
on-screen

1880
Sires Spike

1934
Lives in Berlin,
Germany

1860
Meets Drusilla
on the streets of
London

1898
Along with Spike
and Drusilla,
massacres the
Kalderash tribe

Meets Count
Dracula

1997
Sires Sunnydale High student
Jesse McNally

Is staked to death by Angel

THE WHIRLWIND
A lethal family of vampires

TALENTS
Psychic powers
Hypnosis
Fencing

FIRST WORDS
"Look at all the people.
Are these nice people?"
2-03 School Hard

HEIGHT
5'6"

LAST WORDS
"Poor Spike . . . so lost. Even I
can't help you now."
5-14 Crush

1880
Sires Spike
(then known as
William Pratt)

1997
Is kidnapped and
tortured in Prague;
left highly debilitated

Arrives in Sunnydale
with Spike

Is cured by the blood
of Angel, her sire

1998
Kills Slayer Kendra
Young

Flees to Brazil with
Spike

2001
Returns to
Sunnydale

Finds out that Spike
is in love with Buffy

Leaves Sunnydale
heartbroken

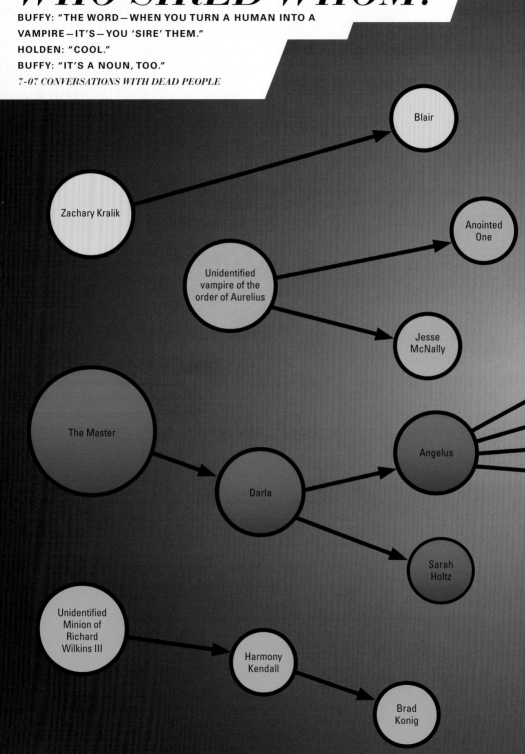

WHO SIRED WHOM?

BUFFY: "THE WORD—WHEN YOU TURN A HUMAN INTO A
VAMPIRE—IT'S—YOU 'SIRE' THEM."
HOLDEN: "COOL."
BUFFY: "IT'S A NOUN, TOO."

7-07 CONVERSATIONS WITH DEAD PEOPLE

Blair

Zachary Kralik

Anointed
One

Unidentified
vampire of the
order of Aurelius

Jesse
McNally

The Master

Angelus

Darla

Sarah
Holtz

Unidentified
Minion of
Richard
Wilkins III

Harmony
Kendall

Brad
Konig

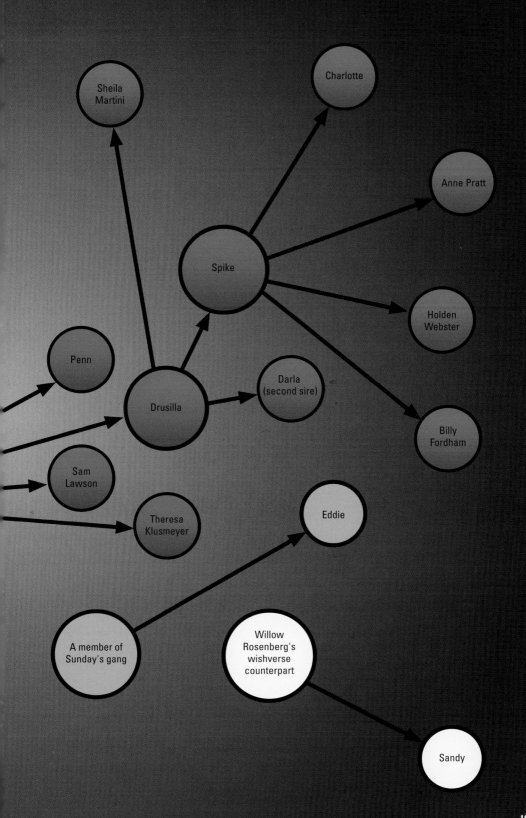

RESPECTING YOUR ELDERS

THERE ARE OLD ONES, AND THERE ARE *VERY* OLD ONES . . .

4.5 billions years ago

Scientists think the Earth is some 4.5 billion years old, but Giles says: "This world is older than any of you know."

He then explains the history of demons: For untold eons demons walked the Earth. They made it their home, their hell. But in time they lost their purchase on this reality. The way was made for mortal animals, for man. *1-02 The Harvest*

13.8 billion years ago

Beljoxa's Eye says that the First Evil has existed "since before the universe was born." Scientists estimate the universe to be some 13.8 billion years old. *7-11 Showtime*

c. 1397

We're not told the age of the Master, but the shooting script of *1-01 Welcome to the Hellmouth* says he was "[b]orn Heinrich Joseph Nest (some six hundred years ago)."

On the DVD commentary for *1-02 The Harvest*, writer Joss Whedon says: "We decided early on that the Master would never be in normal face because he was so old and so far gone. We made him more animalistic than other vampires."

He says the Master has lived so long that he is "devolving." Could that also be true of Kakistos?

1100s

Dawn finds a passage in a book that says, "Tarnis, 12th century. One of the founders of the monks of the Order of Dagon. Their sole purpose appears to have been as protectors of the key." Does this suggest that Glorificus has been around since the 1100s, too? *5-13 Blood Ties*

200,000–100,000 years ago

It is thought the first modern humans evolved in this period. According to Giles, these humans coexisted with the last of the Old Ones.

The books tell that the last demon to leave this reality fed off a human, mixing their blood. He was a human form possessed, infected by the demon's soul. He bit another and another, and so they walk the Earth, feeding, killing some, mixing their blood with others to make more of their kind. Waiting for the animals to die out and the Old Ones to return. *1-02 The Harvest*

200,000–60,000 years ago

At an unknown date, three shamans—whom Buffy calls the Shadow Men—imbued a girl called Sineya with the energy, spirit, and heart of a demon. Sineya became the first Slayer.

In *4-22 Restless*, Sineya says: "I have no speech."

Language is thought to have originated between 200,000 and 60,000 years ago. However, the Shadow Men seen in *7-15 Get It Done* speak, so perhaps they and Sineya are from the more recent past. Buffy can still communicate with Sineya in AD 2003.

[date unknown]

We're not told the age of the ancient vampire Kakistos, but he's "so old that his hands and feet are cloven" *(3-03 Faith, Hope & Trick)*. He has an ancient Greek name. This may suggest he is thousands of years old.

AD 880

In Sjornjost, Sweden, Aud transforms the unfaithful Olaf into a troll and accepts an offer to become the vengeance demon Anyanka. *7-05 Selfless*

1418

The demon Moloch the Corruptor is trapped in the pages of a book in Cortona, Italy. He is freed again in Sunnydale in 1997, more than 500 years later. *1-08 I, Robot . . . You, Jane*

c. 1428

Birth of Vlad III of Wallachia, whom Buffy later meets as the vampire Dracula. *5-01 Buffy vs. Dracula*

BIG BATTLES— THE FIRST EVIL

7-22 CHOSEN

1. Buffy cuts Caleb in two with the M? scythe. (03:00)

2. Buffy leads Faith and the potential Slayers through the Seal of Danzalthar to face the Turok-Han vampires in the cavern below. (23:33)

3. Willow uses M? to turn all the Potentials into Slayers. (25:25)

4. The Slayers battle the Turok-Han vampires. (26:46)

5. Spike's soul and the amulet blast a hole up to the daylight and then direct sunshine into the cavern. (32:15)

6. Buffy and her surviving friends outrun the destruction of Sunnydale. (36:07)

KEY DATES

Before the universe began
According to Beljoxa's Eye, the First Evil already existed.

1998 (Christmas)
The First almost convinces Angel to kill himself, but Angel changes his mind when it snows.

2001
Buffy's second resurrection creates instability in the line of Slayers, giving the First an opportunity to end it.

2002
The First appears to Andrew in Mexico and to Spike in Sunnydale, setting its plan in motion.

2003
Buffy foils the First's plan.

After the collapse of the universe
The First will still exist, apparently.

THE HORROR, THE HORROR

Buffy is stabbed through the chest with a sword and collapses

THE HIGH COST OF WINNING

Amanda, Anya, Spike, and many others die

Rona, Principal Wood, and many others are gravely wounded

Sunnydale is destroyed

WHAT HAPPENS NEXT, AFTER THE END OF THE SHOW?

Giles says there's a Hellmouth in Cleveland and that they have a lot of work ahead.

Willow says there are Slayers awakening everywhere, and Dawn says they should find them.

Faith says Buffy isn't the Chosen One anymore and can live like a normal person.

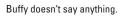

Buffy doesn't say anything.

THE TRIO (JONATHAN LEVINSON, WARREN MEARS, AND ANDREW WELLS)

"SO YOU THREE HAVE WHAT? BANDED TOGETHER TO BE PAINS IN MY ASS?"
—BUFFY, *6-11 GONE*

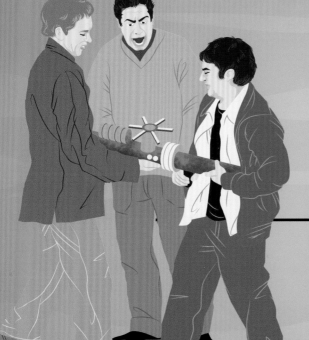

1997
Cordelia picks Jonathan to take her to the prom

1999
Jonathan plans to commit suicide at the top of the school's bell tower

1998
Jonathan becomes possessed by a Bezoar

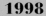

TALENTS
N/A

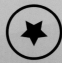

JONATHAN

FIRST WORDS
"Your hands feel kind of . . . rough."
2-04 Inca Mummy Girl

LAST WORDS
"Well, I still care about them. That's why I'm here."
7-07 Conversations with Dead People

LOVES
Being in a gang
Girls
Being liked

HATES
Bullies
Being short
Being bossed around

JONATHAN EPISODE COUNT

28
(19%)

LOVES
Science fiction
Collecting
Comic books

HATES
Bullies
Reality
Being bossed around

25
(17%)

ANDREW EPISODE COUNT

TALENTS
Organization
Pop-culture knowledge
Surviving

2000
Jonathan casts a spell that makes everyone in Sunnydale think he is a superstar

2002
Warren steals the Orbs of Nezzla'Khan

Jonathan and Andrew are arrested, while Warren escapes

Warren kills Tara

Willow kills Warren

Jonathan and Andrew escape to Mexico

Jonathan and Andrew return to Sunnydale

While under the spell of the First Evil, Andrew stabs Jonathan to death

Anya saves Andrew's life

FIRST WORDS
"We can do that."
6-04 Flooded

LAST WORDS
"She was incredible. She died saving my life."
7-22 Chosen

ANDREW

2001
Jonathan meets Warren and Andrew

As the Trio, they hire a demon to rob a bank and attack Buffy

The Trio steals the Illuminata diamond from the Sunnydale Museum of Natural History

16
(11%)

WARREN EPISODE COUNT

FIRST WORDS
"We gotta go, she's gonna see me."
5-15 I Was Made To Love You

LAST WORDS
"Oh, and when you get caught, you'll lose them too. Your friends. You don't want that. I know you're in pain, but—"
6-20 Villains

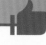

LOVES
Robot girls
Being a villain
Killing

TALENTS
Gadget-building
Stealing stuff
Bossing Andrew and Jonathan around

WARREN

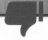

HATES
Real girls
Buffy
Frankie the Jock

NERD SHELF

A QUICK LOOK AT ANDREW'S COLLECTION

BOOKS

Misery
Harry Potter and the Sorcerer's Stone

DVDS

Ocean's Eleven
Back to the Future
Star Wars trilogy
The X-Files
James Bond
Babe
Red Dwarf
SpongeBob Squarepants

Babylon 5
Ghost
Dragon Ball Z
Hellraiser
Dr. Strangelove

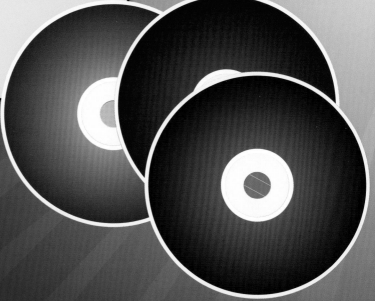

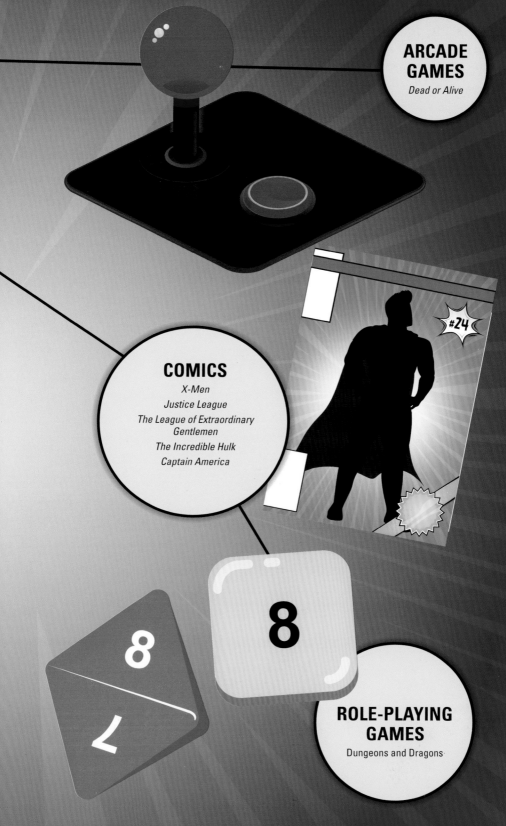

ARCADE GAMES

Dead or Alive

COMICS

X-Men
Justice League
The League of Extraordinary Gentlemen
The Incredible Hulk
Captain America

#24

8

8

7

ROLE-PLAYING GAMES

Dungeons and Dragons

BUFFY AND POP CULTURE

OVER SEVEN SEASONS, BUFFY AND HER FRIENDS
NAME-CHECK MANY CULTURAL ICONS.
HERE ARE JUST A FEW . . .

PLAYS

Death of a
Salesman
Hamlet
Julius Caesar

The Merchant
of Venice
The Rocky
Horror
Picture Show

CRITICS

Roger Ebert
Gene Siskel

COMEDIANS

Buster Keaton
The Three Stooges
The Marx Brothers

MOVIES

The English Patient
The Empire Strikes
Back
The Evil Dead
The Exorcist
Fantasia
Faster, Pussycat! Kill!
Kill!
First Blood
Frankenstein
The Fury
The Full Monty
Ghostbusters
Glitter
Godzilla
Gone with the Wind
The Graduate
Hellraiser
Highlander
The Hunchback of
Notre Dame
Indiana Jones and the
Temple of Doom

Abbott and Costello
Meet Frankenstein
Apocalypse Now
Babe: Pig in the City
Back to the Future
The Bad Seed
Bill and Ted's Bogus
Journey
The Blair Witch Project
Blue Lagoon
Cocktail
Conan the Destroyer
Creature from the
Black Lagoon
Dracula (1973)

James Bond films
Jaws
Jaws 3-D
The Lost Weekend
The Little Rascals
JFK
Magnolia
Marathon Man
Mary Poppins
The Matrix
Misery
Miss Congeniality
Mommie Dearest
Moulin Rouge!
My Fair Lady
The Phantom Menace
Planet of the Apes
Ocean's Eleven
One Million Years B.C.
Poltergeist
Pretty in Pink
Private Benjamin

Pump Up the Volume
Return of the Jedi
The Seventh Seal
Signs
Sleepless in Seattle
The Shining
The Sound of Music
Steel Magnolias
The Stepford Wives
This Is Spinal Tap
Thelma & Louise
The Terminator
The Usual Suspects
The Wedding Planner
The Wild Bunch
Witness

POEMS

"The Death of the
Hired Man"
"Marmion"
"Stopping by Woods on
a Snowy Evening"

OPERA
Don Giovanni
Madame Butterfly

WRITERS
Maya Angelou
Samuel Beckett
Helen Keller
Ernest Hemingway
Anne Rice

COMICS
The Avengers
Batman
Captain America
The Incredible Hulk
Justice League
The League of Extraordinary Gentlemen
Spider-Man
Superman
Super Friends
Wonder Woman
X-Men

MAGAZINES
Esquire
Reader's Digest
Vanity Fair

BOOKS
The Call of the Wild
The Cask of Amontillado
A Christmas Carol
The Deep End of the Ocean
Harry Potter
The Lord of the Rings
Nausea
Rebecca of Sunnybrook Farm
Sherlock Holmes
1984
Of Human Bondage
On the Road
Strange Case of Dr. Jekyll and Mr. Hyde
Uncle Tom's Cabin
The Vampire Chronicles

ACTORS
Kevin Bacon
Antonio Banderas
Humphrey Bogart
Matthew Broderick
Chevy Chase
George Clooney
Tom Cruise
Ellen DeGeneres
Marlene Dietrich
Farrah Fawcett
Nicole Kidman
Gwyneth Paltrow
Christina Ricci
Molly Ringwald
James Spader
Charlize Theron
John Wayne

DIRECTORS
Ken Russell

TV
The A-Team
The Addams Family
Babylon 5
Candid Camera
Charlie's Angels
A Charlie Brown Christmas
CSI
Dawson's Creek
Doctor Who
Doogie Howser, M.D.
Dragnet
ER
Falcon Crest
Gentle Ben
H.R. Pufnstuf
Jeopardy
Knight Rider
Looney Tunes
The Lone Ranger
Manimal
Mighty Morphin Power Rangers
Mighty Mouse
Monty Python's Flying Circus
Mr. Belvedere
Murder, She Wrote
Nightline
The Oprah Winfrey Show
Oz
Passions
The Prisoner
The Real World
Red Dwarf
Scooby-Doo, Where Are You!
Sesame Street
The Simpsons
SpongeBob SquarePants
Star Trek
Star Trek: Enterprise
Star Trek: The Next Generation
Super Friends
Teletubbies
The X-Files
Walker, Texas Ranger
War Games
Wheel of Fortune
Xena: Warrior Princess

PAINTERS
Claude Monet
Gustav Klimt
Vincent van Gogh
Grant Wood

WHAT'S MY LINE?

CHARACTERS NAMING THE EPISODE THEY'RE IN

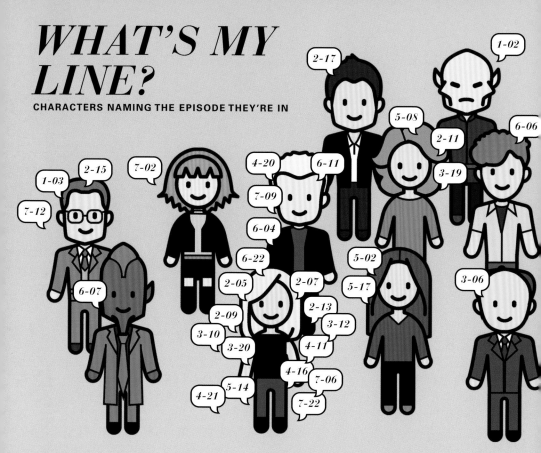

1-02 The Harvest The Master: "She mustn't be allowed to interfere with the Harvest!"

1-03 Witch Giles: "This witch is casting horrible and disfiguring spells . . ."

1-06 The Pack Zookeeper: "Once they separate him, the pack devours them."

1-07 Angel Willow: "What about Angel?"

1-10 Nightmares Wendell Sears: "That's when the nightmares started."

2-05 Reptile Boy Buffy: "Hey, reptile boy!"

2-06 Halloween Willow: "Snyder must be in charge of the volunteer safety program for Halloween this year."

2-07 Lie to Me Buffy: "And don't lie to me."

2-09 What's My Line (Part 1) Buffy: "Well, then you know it's a whole week of *What's My Line?*"

2-11 Ted Joyce: "Buffy, this is Ted."

2-13 Surprise Buffy: "Surprise me."

2-15 Phases Giles: "The phases of the moon do seem to exert a great deal of psychological influence."

2-17 Passion Angelus: "Passion."

3-01 Anne Rickie Thomas: "I think we're good, um, Anne."

3-02 Dead Man's Party Oz: "I think the dead man's party moved upstairs."

3-05 Homecoming Willow: "And it is our last Homecoming Dance."

3-06 Band Candy Principal Snyder: "It's band candy."

3-10 Amends Buffy: "Angel, you have the power to do real good, to make amends."

3-11 Gingerbread Xander: "Breadcrumbs, ovens, gingerbread house?"

3-12 Helpless Buffy: "What if I just hide under my bed, all scared and helpless?"

3-13 The Zeppo Cordelia: "You're the Zeppo."

3-19 Choices Joyce: "I'm just so pleased that you have so many choices."

3-20 The Prom Buffy: "Like after the prom."

4-05 Beer Bad Xander: "Beer bad."

4-07 The Initiative Professor Walsh: "Fail to recapture it and everything we've worked for–the Initiative itself– could end tonight."

4-11 *Doomed* Buffy: "It's just doomed."

4-16 *Who Are You?* Buffy (in Faith's body): "Who are you?"

4-20 *The Yoko Factor* Spike: "It's called the Yoko factor."

4-21 *Primeval* Buffy: "Messing with primeval forces you have absolutely no comprehension of."

5-02 *Real Me* Dawn: "Nobody knows who I am, not the real me."

5-06 *Family* Intern: "Got her family out there."

5-08 *Shadow* Joyce: "A shadow."

5-14 *Crush* Buffy: "You have a crush on him."

5-16 *The Body* 911 operator (a telephone): "The body's cold?"

5-17 *Forever* Dawn: "She's the one who has to be in it forever."

5-18 *Intervention* Willow: "Intervention time again?"

6-04 *Flooded* Spike: "Did you know this place was flooded?"

6-06 *All the Way* Zack: "But what about, you know, going all the way?"

6-07 *Once More, with Feeling* Sweet: "Say you're happy now, once more with feeling."

6-08 *Tabula Rasa* Willow: "Tabula rasa, tabula rasa, tabula rasa."

6-11 *Gone* Spike: "Yeah, well, the fact is my lighter's gone missing."

6-21 *Two to Go* Anya: "So we're talking about 'two to go,' right—Jonathan and whatshisface, the other guy?"

6-22 *Grave* Buffy: "It was like when I clawed my way out of that grave."

7-02 *Beneath You* German girl: "From beneath you it devours."

7-04 *Help* Xander: "I wanna help."

7-06 *Him* Buffy: "The school basement is making him crazy."

7-09 *Never Leave Me* Spike: "Oh, never leave me."

7-11 *Showtime* Willow: "It's showtime."

7-12 *Potential* Giles: "Potential Slayers."

7-20 *Touched* Robin Wood: "We all want someone who cares, to be touched that way."

7-22 *Chosen* Buffy: "I hate that there's evil and that I was chosen to fight it."

SUNNYDALE HALL OF FAME

A ROUNDUP OF ACTORS WITH MINOR ROLES IN THE SHOW
WHO WENT ON TO BECOME STARS

AMY ADAMS

(Beth Maclay, *5-06 Family*)
Arrival
American Hustle
Man of Steel

JASON BEHR

(Billy Fordham, *2-07 Lie to Me*)
Dawson's Creek
The Grudge

RACHEL BILSON

(Colleen, *7-18 Dirty Girls*)
The O.C.

FELICIA DAY

(Vi, *7-11 Showtime*)*
Supernatural
Dr. Horrible's Sing-Along Blog
The Guild

ASHANTI DOUGLAS

(Lissa, *7-14 First Date*)
Grammy Award–winning singer
John Tucker Must Die
The Muppets' Wizard of Oz

CLEA DUVALL

(Marcie Ross, *1-11 Out of Mind, Out of Sight*)
Argo
Carnivàle
Girl, Interrupted

JOHN HAWKES

(George, *2-19 I Only Have Eyes for You*)
Lincoln
The Sessions
Deadwood

NATHAN FILLION

(Caleb, *7-18 Dirty Girls*)*
Castle
Serenity
Firefly

KAL PENN

(Hunt, *4-05 Beer Bad*)
Harold and Kumar

* First appearance.

EPISODE-BY-EPISODE GUIDE

AN OVERVIEW OF RATINGS AND RANKINGS FOR THE WHOLE SHOW

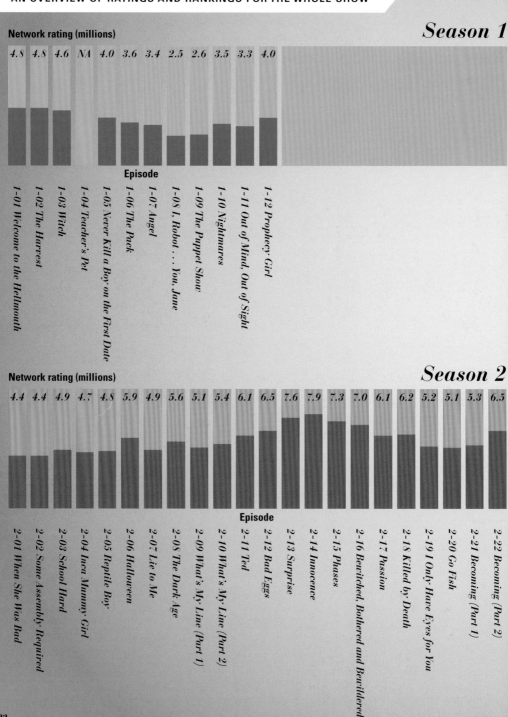

Season 1

Network rating (millions)

| 4.8 | 4.8 | 4.6 | NA | 4.0 | 3.6 | 3.4 | 2.5 | 2.6 | 3.5 | 3.3 | 4.0 |

Episode

- 1-01 Welcome to the Hellmouth
- 1-02 The Harvest
- 1-03 Witch
- 1-04 Teacher's Pet
- 1-05 Never Kill a Boy on the First Date
- 1-06 The Pack
- 1-07 Angel
- 1-08 I, Robot . . . You, Jane
- 1-09 The Puppet Show
- 1-10 Nightmares
- 1-11 Out of Mind, Out of Sight
- 1-12 Prophecy Girl

Season 2

Network rating (millions)

| 4.4 | 4.4 | 4.9 | 4.7 | 4.8 | 5.9 | 4.9 | 5.6 | 5.1 | 5.4 | 6.1 | 6.5 | 7.6 | 7.9 | 7.3 | 7.0 | 6.1 | 6.2 | 5.2 | 5.1 | 5.3 | 6.5 |

Episode

- 2-01 When She Was Bad
- 2-02 Some Assembly Required
- 2-03 School Hard
- 2-04 Inca Mummy Girl
- 2-05 Reptile Boy
- 2-06 Halloween
- 2-07 Lie to Me
- 2-08 The Dark Age
- 2-09 What's My Line (Part 1)
- 2-10 What's My Line (Part 2)
- 2-11 Ted
- 2-12 Bad Eggs
- 2-13 Surprise
- 2-14 Innocence
- 2-15 Phases
- 2-16 Bewitched, Bothered and Bewildered
- 2-17 Passion
- 2-18 Killed by Death
- 2-19 I Only Have Eyes for You
- 2-20 Go Fish
- 2-21 Becoming (Part 1)
- 2-22 Becoming (Part 2)

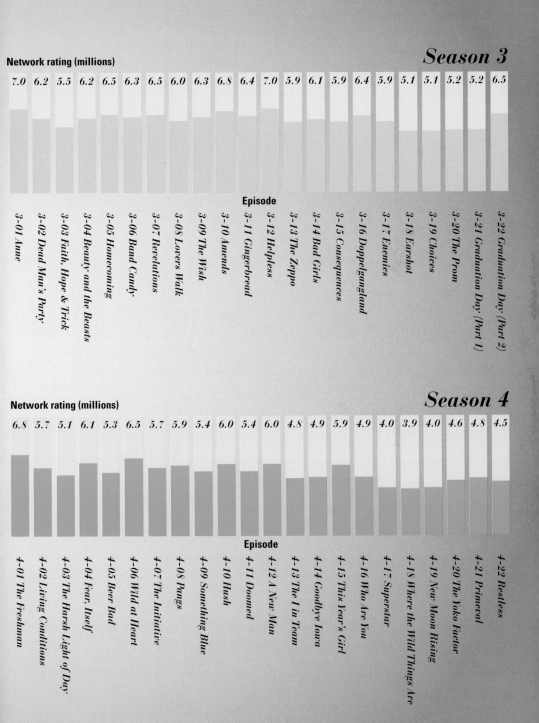

Network rating (millions)

Season 3

| 7.0 | 6.2 | 5.5 | 6.2 | 6.5 | 6.3 | 6.5 | 6.0 | 6.3 | 6.8 | 6.4 | 7.0 | 5.9 | 6.1 | 5.9 | 6.4 | 5.9 | 5.1 | 5.1 | 5.2 | 5.2 | 6.5 |

Episode

3-01 Anne
3-02 Dead Man's Party
3-03 Faith, Hope & Trick
3-04 Beauty and the Beasts
3-05 Homecoming
3-06 Band Candy
3-07 Revelations
3-08 Lovers Walk
3-09 The Wish
3-10 Amends
3-11 Gingerbread
3-12 Helpless
3-13 The Zeppo
3-14 Bad Girls
3-15 Consequences
3-16 Doppelgangland
3-17 Enemies
3-18 Earshot
3-19 Choices
3-20 The Prom
3-21 Graduation Day (Part 1)
3-22 Graduation Day (Part 2)

Network rating (millions)

Season 4

| 6.8 | 5.7 | 5.1 | 6.1 | 5.3 | 6.5 | 5.7 | 5.9 | 5.4 | 6.0 | 5.4 | 6.0 | 4.8 | 4.9 | 5.9 | 4.9 | 4.0 | 3.9 | 4.0 | 4.6 | 4.8 | 4.5 |

Episode

4-01 The Freshman
4-02 Living Conditions
4-03 The Harsh Light of Day
4-04 Fear, Itself
4-05 Beer Bad
4-06 Wild at Heart
4-07 The Initiative
4-08 Pangs
4-09 Something Blue
4-10 Hush
4-11 Doomed
4-12 A New Man
4-13 The I in Team
4-14 Goodbye Iowa
4-15 This Year's Girl
4-16 Who Are You
4-17 Superstar
4-18 Where the Wild Things Are
4-19 New Moon Rising
4-20 The Yoko Factor
4-21 Primeval
4-22 Restless

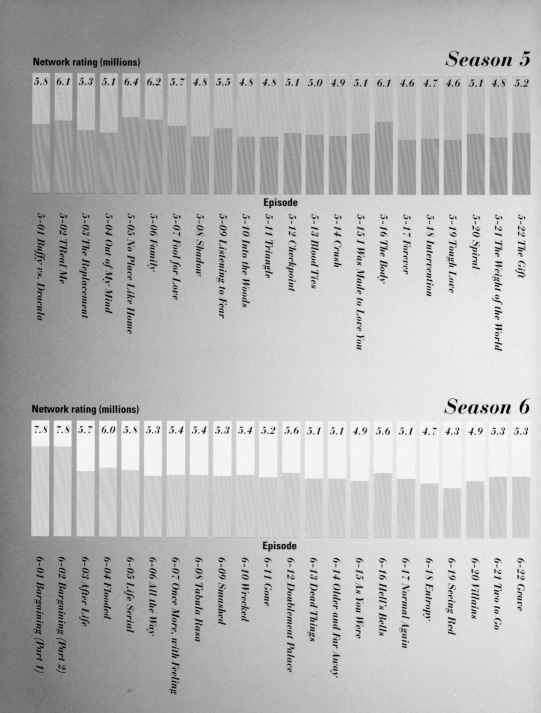

Network rating (millions)

Season 5

| 5.8 | 6.1 | 5.3 | 5.1 | 6.4 | 6.2 | 5.7 | 4.8 | 5.5 | 4.8 | 4.8 | 5.1 | 5.0 | 4.9 | 5.1 | 6.1 | 4.6 | 4.7 | 4.6 | 5.1 | 4.8 | 5.2 |

Episode

| 5-01 Buffy vs. Dracula | 5-02 TReal Me | 5-03 The Replacement | 5-04 Out of My Mind | 5-05 No Place Like Home | 5-06 Family | 5-07 Fool for Love | 5-08 Shadow | 5-09 Listening to Fear | 5-10 Into the Woods | 5-11 Triangle | 5-12 Checkpoint | 5-13 Blood Ties | 5-14 Crush | 5-15 I Was Made to Love You | 5-16 The Body | 5-17 Forever | 5-18 Intervention | 5-19 Tough Love | 5-20 Spiral | 5-21 The Weigh of the World | 5-22 The Gift |

Network rating (millions)

Season 6

| 7.8 | 7.8 | 5.7 | 6.0 | 5.8 | 5.3 | 5.4 | 5.4 | 5.3 | 5.4 | 5.2 | 5.6 | 5.1 | 5.1 | 4.9 | 5.6 | 5.1 | 4.7 | 4.3 | 4.9 | 5.3 | 5.3 |

Episode

| 6-01 Bargaining (Part 1) | 6-02 Bargaining (Part 2) | 6-03 After Life | 6-04 Flooded | 6-05 Life Serial | 6-06 All the Way | 6-07 Once More, with Feeling | 6-08 Tabula Rasa | 6-09 Smashed | 6-10 Wrecked | 6-11 Gone | 6-12 Doublemeat Palace | 6-13 Dead Things | 6-14 Older and Far Away | 6-15 As You Were | 6-16 Hell's Bells | 6-17 Normal Again | 6-18 Entropy | 6-19 Seeing Red | 6-20 Villains | 6-21 Two to Go | 6-22 Grave |

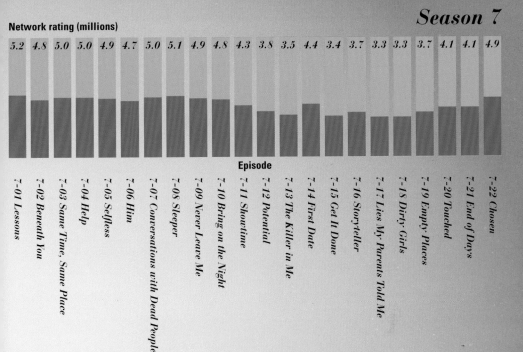

Network rating (millions)

Season 7

| 5.2 | 4.8 | 5.0 | 5.0 | 4.9 | 4.7 | 5.0 | 5.1 | 4.9 | 4.8 | 4.3 | 3.8 | 3.5 | 4.4 | 3.4 | 3.7 | 3.3 | 3.3 | 3.7 | 4.1 | 4.1 | 4.9 |

Episode

7-01 Lessons
7-02 Beneath You
7-03 Same Time, Same Place
7-04 Help
7-05 Selfless
7-06 Him
7-07 Conversations with Dead People
7-08 Sleeper
7-09 Never Leave Me
7-10 Bring on the Night
7-11 Showtime
7-12 Potential
7-13 The Killer in Me
7-14 First Date
7-15 Get It Done
7-16 Storyteller
7-17 Lies My Parents Told Me
7-18 Dirty Girls
7-19 Empty Places
7-20 Touched
7-21 End of Days
7-22 Chosen

2-14 Innocence
WINNER of Emmy for Outstanding Makeup for a Series

2-21 Becoming (Part 1)
WINNER of Emmy for Outstanding Music Composition for a Series

4-05 Beer Bad
NOMINATED for Emmy for Outstanding Hairstyling for a Series

4-10 Hush
NOMINATED for Emmys for Outstanding Cinematography for a Single Camera Series and for Outstanding Writing for a Drama Series

5-16 The Body
NOMINATED for Nebula Award for Best Script

6-07 Once More, with Feeling
NOMINATED for Emmy for Outstanding Music Direction, for Hugo Award for Best Dramatic Presentation, and for Nebula Award for Best Script

6-16 Hell's Bells
NOMINATED for Emmys for Outstanding Hairstyling for a Series, for Outstanding Makeup (non-prosthetic) for a Series, and for Outstanding Makeup (prosthetic) for a Series

7-07 Conversations with Dead People
WINNER of Hugo Award for Best Dramatic Presentation, Short Form

7-22 Chosen
NOMINATED for Emmy for Outstanding Special Visual Effects for a Series, and for Hugo Award for Best Dramatic Presentation, Short Form

ACKNOWLEDGMENTS

Thanks to the cast and crew of *Buffy the Vampire Slayer*—
not that they were directly involved in this book, but for
giving us so much to sink our fangs into. We're also very
grateful to everyone at 20th Century Fox and the team at
Insight Editions for their generosity and patience.

Simon would like to thank Samira Ahmed, Simon Belcher,
Debbie Challis, Jessica Eastwood, and Gemma Romain.

Steve would like to thank Britt O'Brien, Lizzie Rogers,
Jayne Nelson, and Alex Drew.

INSIGHT
EDITIONS

www.insighteditions.com

Find us on Facebook:
www.facebook.com/InsightEditions

Follow us on Twitter: @insighteditions

Library of Congress Cataloging-in-Publication Data available.

ISBN: 978-1-68383-056-6

Publisher: Raoul Goff
Associate Publisher: Vanessa Lopez
Art Director: Chrissy Kwasnik
Senior Designer: Stuart Smith
Senior Editor: Rossella Barry
Managing Editor: Alan Kaplan
Senior Production Editor: Rachel Anderson
Editorial Assistant: Tessa Murphy
Production Manager: Sam Taylor

Illustrations by Ilaria Vescovo, Tomato Farm Agency

Insight Editions would like to thank Laura Kavanagh for her important editorial help.

 REPLANTED PAPER

Insight Editions, in association with Roots of Peace, will plant two trees for each tree used in the manufacturing of this book. Roots of Peace is an internationally renowned humanitarian organization dedicated to eradicating land mines worldwide and converting war-torn lands into productive farms and wildlife habitats. Roots of Peace will plant two million fruit and nut trees in Afghanistan and provide farmers there with the skills and support necessary for sustainable land use.

Manufactured in China by Insight Editions

10 9 8 7 6 5 4 3 2 1